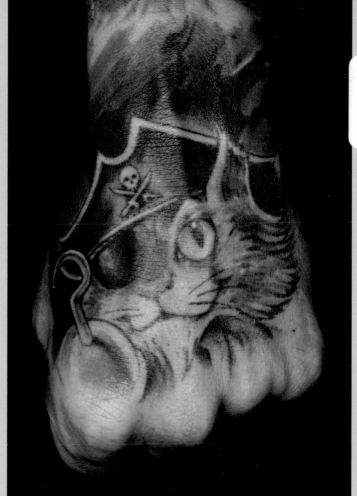

TATTOOS

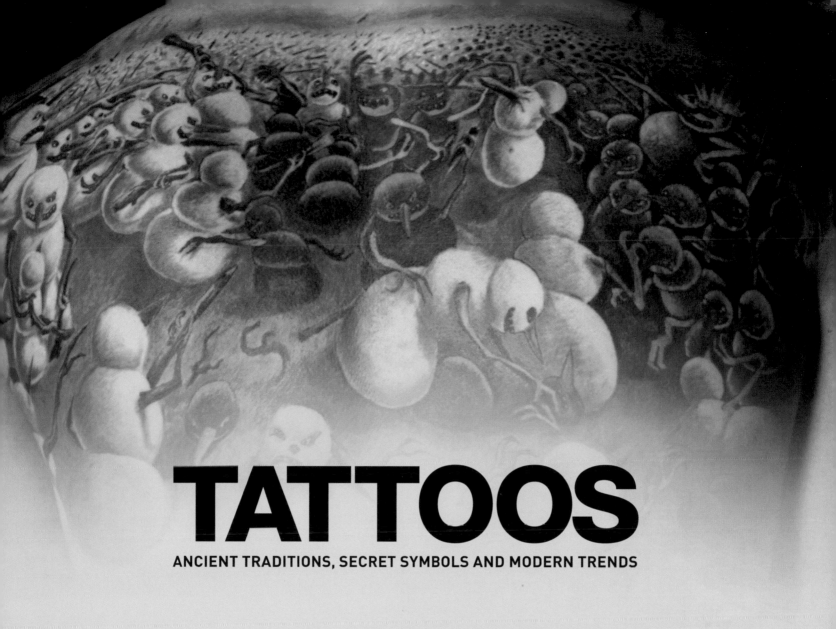

TATTOOS

ANCIENT TRADITIONS, SECRET SYMBOLS AND MODERN TRENDS

Doralba Picerno

CHARTWELL
BOOKS, INC.

Picture Acknowledgements

All photography © Doralba Picerno, except:

Corbis: 8, 11 (2), 16.

Getty Images: 18 (Jose CABEZAS/AFP/Getty Images).

Wikimedia Commons: 10, 17.

Page 96 *Li I, Work No. 250* © 1974, H.R. Giger, 70 x 100cm, photogravure, Edition 170. Courtesy of HRGigerMuseum.com

Page 97 *Biomechanical Landscape, Work No. 312* ©1976, H.R. Giger, 200 x 140cm, acrylic on paper/wood. Courtesy of HRGigerMuseum.com

Page 98 *Necronom IV, Work No. 303,* ©1976, H.R. Giger, 100 x 150 cm, Acrylic on paper/wood. Courtesy of HRGigerMuseum.com

Opener tattoos by **1** *Bez, Triplesix Studios, Sunderland* **22** *Slim D, Kreuzberg, Berlin, Germany* **38** *Patrick B, Squid Ink, Folkestone, UK* **68** *Andreas, South of Heaven, Sweden* **76** *Leo, Naked Trust, Salzburg, Austria* **84** *Mr Buzz, Abergavenny, UK* **92** *Filippo, Frosinone, Italy* **106** *Joao Bosco, Self Sacrifice, London, UK* **114** *Miss Nico, Berlin, Germany* **120** *Anabi Tattoo, Szczecin, Poland*

This edition published in 2013 by

CHARTWELL BOOKS, INC.

A Division of **BOOK SALES, INC.**

276 Fifth Avenue Suite 206
New York, New York 10001 USA

Copyright © 2011 Arcturus Publishing Limited

Project editor: Jessica Cole

ISBN: 978-0-7858-2939-3
AD001801EN

Printed in Singapore

Contents

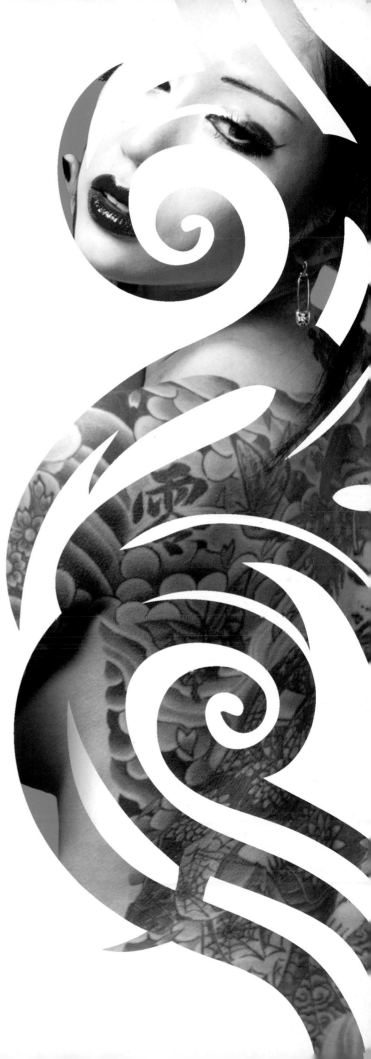

Introduction

Here in the 21st century, tattoos are everywhere. It seems a lifetime ago – though in truth it is nowhere close – that tattooed people were regarded with distaste, suspicion, or downright contempt, associated as they were in the public consciousness with gang culture, crime and irresponsibility. How times have changed! Tattooed pin-ups stare at us from magazine covers; we see people with body art on primetime television; a heavily decorated person on the street might not even turn our head. And so it should be. We seem to have overcome centuries of prejudices and are learning to welcome the individuality that comes with having your skin permanently marked.

This gradual reformation in social attitudes has seen the advent of not only tolerance but of a true appreciation of this outstanding art form. Many factors have governed this change, but above all it is the sheer quality of the work that, today, allows tattoos to speak for themselves. The last two decades have brought a refinement of, and a revolution in, tattooing techniques, as well as a fresh generation of artists who have brought new aesthetic sensibilities into the tattoo arena. Once covered up and hidden from view, tattoos today are now conspicuously and proudly on display for all to admire. And while this open-mindedness might not – yet – be universal, it is widespread enough to mark a significant change in social mores.

But this is no modern, new-fangled trend: tattooing has been around for millennia. Indeed,

It is not unusual for people to draw inspiration from works of art for their tattoos, in this case the art nouveau illustrations of Alphonse Mucha. *Tattoo by Matt, No Pain No Brain, Berlin*

it is one of the oldest forms of body decoration and visible communication. We have seen evidence of permanent body markings from hieroglyphics found on mummies from the Egyptian and Neolithic eras. Interestingly enough, all tattooed Egyptian mummies found so far happen to be female. This might seem to indicate that only women were tattooed at the time of the pharaohs, but wall inscriptions, statuettes with distinct body markings and writings which refer to body designs have been found, all of which suggest that tattooing was practised on both genders.

Evidence of tattooing and of various tattoo implements dating back to the Paleolithic era exists in Japan and continental Europe, providing proof that primitive forms of tattooing were practised some 10,000 years ago: grooved bone needles, believed to have been used for the purpose of marking skin, were found with other tools in a Paleolithic cave excavation in France. But the first human remains to be found bearing tattoos are from only 5,300 years ago. This was the time a man affectionately nicknamed 'Ötzi the Iceman' is believed to have lived. Found in the Northern Italian Alps, his is the oldest mummified body ever found, and it bears distinct tattoo marks.

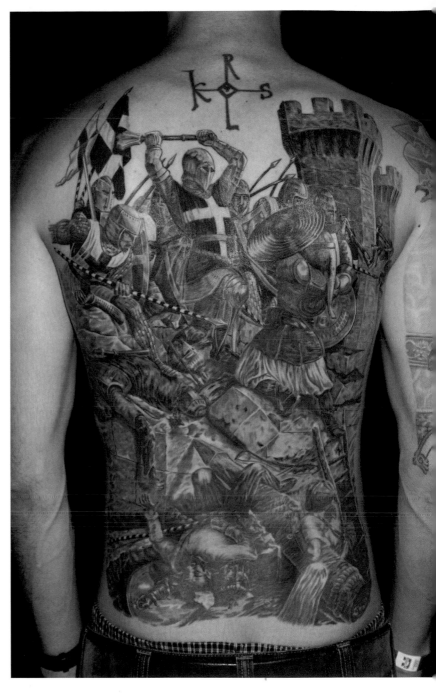

A large historical backpiece depicting a battle scene from the crusades. *Tattoo by Gerhard, Art Factory, Echsenbach, Austria*

Tattooing in tribal societies past and present has long been used to communicate a social status, to mark an achievement or an affiliation, or to invoke protection, and

in ancient and in relatively recent times it has been considered an important rite of passage into adulthood and into a particular social role. Tattoos have also been used to ward off evil, to mark someone's courage, for embellishment and for punishment. Early tattoos were not figurative, as they tend to be now. They consisted mostly of dots and lines which were positioned on visible parts of the body as a means of non-verbal communication.

The most fundamental shift in emphasis between those early tattoos and their recent counterparts is the relevance those tattoos have in communicating with other people. These days, it is still true that a lot of work may be done to make a deliberate statement to the world – comparable, perhaps, to those tribal marks of social status – but many today wear tattoos for their own enjoyment, as a statement to themselves only, and not to the wider world. And whichever the motivation, a tattoo is almost always a personal, not a social, decision: a tattoo is a sign of our individuality, a personal statement to a audience, wide or small, of our own choosing.

The word 'tattoo' has an exotic origin: it comes from the Polynesian 'tatau', itself an onomatopoeic word derived from the noise made by the tapping of tattoo sticks used in hand-tapped tattoos. The word was introduced to the West as 'tataw', which was then adapted to its modern Western incarnation.

It was sailors and explorers in the 18th century who first came into contact with tattooed tribes in Polynesia and brought back the art form to the West, although using

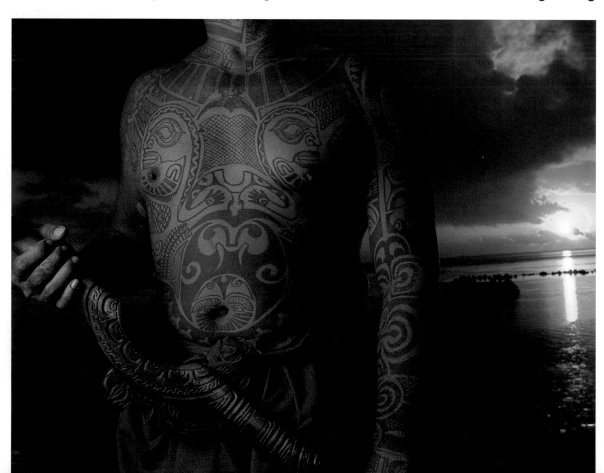

A Polynesian tribal body suit. This type of work incorporates a variety of symbols unique to the wearer's culture, which can represent his status in his community, his achievements or his affiliations

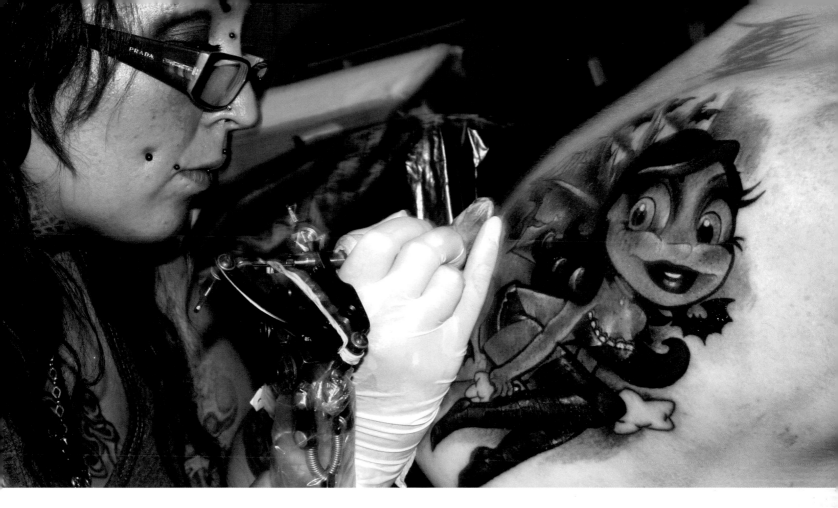

Tattooing techniques have advanced in leaps and bounds since the early days of the craft. The sophisticated machines of today allow for a greater degree of subtle shading and have allowed tattoo work to blossom into the highly evolved art form that it is today

rather a different *modus operandi* from the Eastern technique which included pushing dark plant dyes into the skin, or rubbing ash into open wounds to leave a mark. The original rotary tattoo machine was invented by Thomas Edison and patented to be used for engravings. It was altered a few years later to accommodate an ink supply and tattoo needles. A machine is powered through two electromagnetic coils that move a bar to which the needles are fixed. Nowadays, the equipment available is very sophisticated and allows the artists to control the speed and depth of needle insertion, enabling them to create subtle nuances. Sometimes artists will use different machines, equipped with different sets of needles, depending on whether they are tattooing an outline or doing the shading. But despite the general departure from the early tribal techniques, there are artists who have embraced traditional methods which they have learnt from native masters, specializing in the use of manual equipment which needs to be tapped or poked into the skin to inject the ink into the dermis.

* * *

When the sailors of the 18th century introduced 'tataw' back home, it was a concept that for many years held a deeply negative connotation. The perception of tattooed people as marked criminals or circus freaks was rooted in the public consciousness for a long time.

One of the star attractions of the 20th century was the Great Omi, a man with a tribal bodysuit who appeared in sideshows throughout the English-speaking world. Ostensibly tattooed by New Guinea tribesmen against his will when taken prisoner during an expedition, the Great Omi, also known as the Zebra Man, was in fact an ex-army major called Horace Ridler who had been tattooed by London-based artist George Burchett (the celebrity tattoo artist of his day, rumoured to have had European royalty on his client list). Finding himself in financial trouble after the First World War, Ridler turned to the circus for his livelihood and began his transformation. After getting a full body suit, he decided to add more work to make himself more marketable: by adding tattoos to his face as well as other body modifications, he made himself truly unique and became a sell-out attraction.

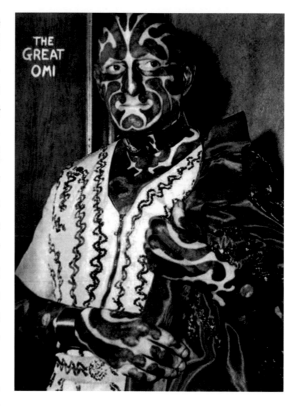

The Great Omi, a famous sideshow attraction in the first half of the 20th century. Allegedly forcibly marked by New Guinea tribesmen, he was in reality tattooed in East London by George Burchett

The stereotypical circus performer commonly known, in those days, as the 'tattooed man' (or the more sensational 'tattooed lady') has marked our perception of tattooed folk for decades: tattoos were firmly reserved for sideshow acts, people on the edge of society. It was a prejudice exacerbated by the inked criminals and gangsters proudly sporting their marks to advertise their affiliations and alleged toughness. To add insult to injury, their tattoos were also of exceedingly low quality. There were plenty of people with better designs who might have lent the art form some credibility, but unless they were in the tattoo business, they prudently kept them covered up.

The aesthetics and inner meanings and symbolism of prison tattoos could – and frequently do – fill entire books of their own. Most are very territorial and culturally defined within specific nationalities, and too nuanced to do true justice to in so few pages. These rough and unrefined tattoos are, historically, made with rudimentary homemade machines which sometimes just use needles and ink. Laden with meaning, the tattoos tell a story with visual symbols. A classic prison tattoo is, for instance, the teardrop(s) near the eye: originally a counter for the people the wearer had killed, it has come to signify the number of lost loved ones or the number of terms spent in prison. Five or three dots in a specific pattern on the dorsal side of the hand between index finger and thumb are also a mark of inmates. The symbolism of Russian prison tattoos is notoriously complex and varies depending on its position on the body, indicating gang affiliation, crime committed, sentence received, and so on.

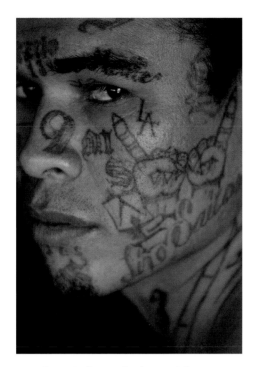

A typical example of a prison facial tattoo, which appears not to have been applied according to an overall harmonious design. Its permanence reminds the wearer that gang membership is a lifelong commitment

The appeal of tattoos in jails is easy to see: in a place where all freedoms are confiscated, marking one's own skin is the one thing that cannot be taken away, a last bastion of individuality in an environment that is designed to dehumanize. Due to the lack of sterilizing facilities, the risk of cross-contamination in prisons is, unsurprisingly, extremely high. Needless to say, it doesn't stop inmates from getting their mark. The quality of jail tattoo work has improved, although the artistry of the tattooist is usually severely hindered by the quality of the makeshift machines, which sometimes utilize guitar strings as needles, and the substance of the inks used (urine or shampoo mixed with soot, for instance). Today, as the glamour and popularity of the tattoo world reaches new heights the world over, the media representation of prison tattoos is glorified and embellished: even the characters in the television series *Prison Break* wear exquisitely executed body suits. A departure from reality, to be sure, but also a telling sign of the changing times.

Tattooing has been made even more mainstream and trendy by the runaway success of US reality television shows *Miami Ink* (first aired in 2005) and *LA Ink*, which in turn spawned Brazilian and European spin-offs, *Rio Ink* and *London Ink*, as well as several other tattoo-related programmes. The shows have made stars of their featured tattooists, the biggest of them all being the star of *LA Ink*, Kat Von D, who has been catapulted into a multimedia career spanning books, make-up and clothing lines, as well as a celebrity status with her high-profile boyfriends. People with no previous interest in or understanding of the tattooing process are now fans of these shows, which have no doubt contributed to popularize what was once an underground practice.

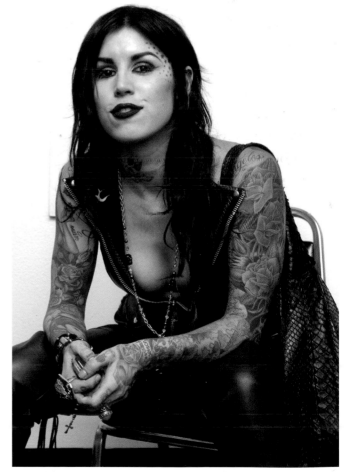

Kat Von D, the star tattooist of *LA Ink* who has become a celebrity due to her TV appearances. As well as being a renowned tattoo artist, she has published two best-selling books and has a clothing and a make-up line.

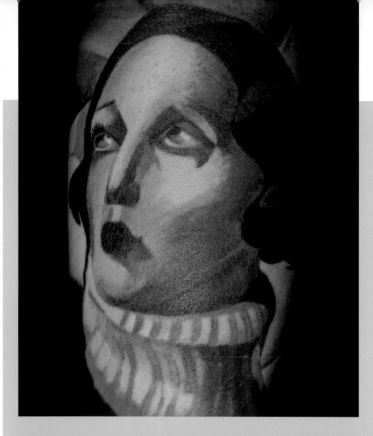

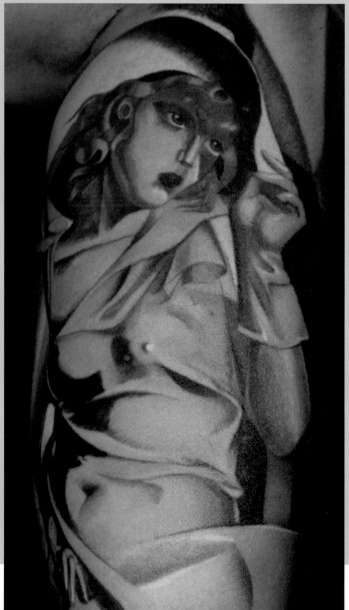

Art imitating art

As you can see from these pages, there is no question that tattooing is a *bona fide*, and extraordinary, art form. It has its own techniques, styles, genres and collectors, and the work is highly prized by its owners. And yet, however valuable one's own tattoo work may be, it is not a transferable commodity, unlike other types of artistic expression, rendering it worthless to anyone else in monetary terms.

What draws tattooing closer to painting and drawing is the way in which these genres cross-pollinate: one type of artistic expression feeds the other. It is perhaps surprising that such an innovative and radical art form as tattooing generates some of the most retrospective and recycled of contemporary art work, borrowing as it does so liberally from every genre of the world's rich artistic heritage. Yet perhaps such an approach should be expected from a genre that is characterized by its fluidity and versatility. Art styles that we would ordinarily associate with a specific movement, be they Classical, art deco or graffiti, are regularly transformed and reborn as skin decoration. It is precisely this subversion of our expectations that makes tattoo art so powerful and so beguiling.

And conversely, we can also see how tattoos inspire other forms of art. The flourishing of galleries for so-called low-brow art — works inspired by tattoos, comic book art and commercial illustrations — shows that there is a growing market for this genre. Many tattoo artists also express themselves in paintings, which are often exhibited in dedicated art spaces in some of the larger tattoo conventions. Tattoos have inspired fashion lines, jewellery and designer accessories. It is clear that the symbiotic relationship between all these forms of self-expression is very much alive.

In some of the most innovative tattoo work of recent years, tattoo lines are made to look like rough pencil drawings, while others take direct inspiration from sophisticated illustrations and graphic work. Some artists tattoo as if they were painting, turning the tattoo gun into a dispenser of delicate and expressive brushstrokes. In a handful of cases, the tattooists' unique and distinctive styles are so sought-after that they are commissioned for 'freehand' pieces which are created bespoke for the client. The bearer becomes akin to an art collector in possession of a unique and, literally, priceless canvas — his or her own skin.

Tattoos by Junior Ink, Warsaw, Poland

★ TRAILBLAZERS

Bugs

One of the most talented and copied contemporary tattooists is French tattoo artist Bugs. Once a celebrated pioneer of the Celtic genre, Bugs successfully initiated several tattoo trends before settling, for the time being at least, on a cubist-inspired type of painterly tattoo work. It will not come as a surprise that Bugs is also a renowned painter — one glance at his masterful tattoos reveals a delicate artist's touch. He applies colour as if using a paintbrush, and yet his tattoo work is not so crude as to appear as a painting transposed on skin. It is organic and fluid — and utterly original.

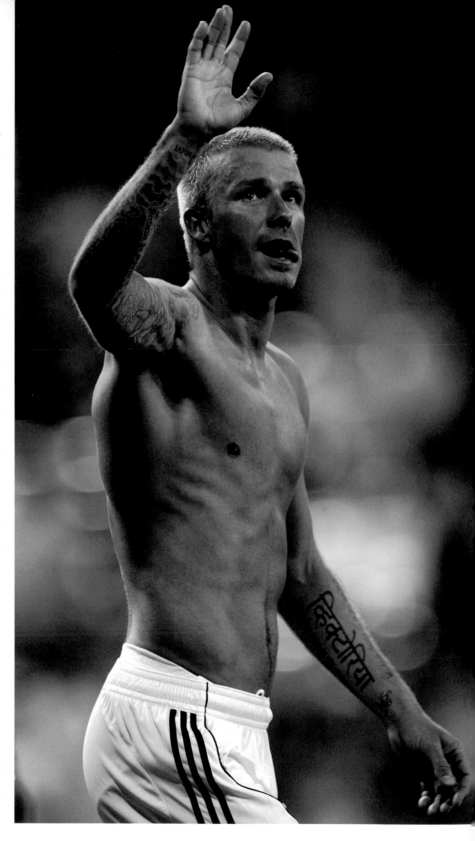

In the celebrity arena of the past it was only hard-living rockers who sported tattoos. Now it's A-list movie stars, footballers and mainstream celebrities: role models for the young who so often wish to emulate them. Famous tattooed people who take pride in their tattoos are often a very good advertisement for the tattoo industry; those like Angelina Jolie or David Beckham not only have tattoos, but they have very high-quality ones. It is sometimes baffling to see a millionaire footballer with a shoddy tattoo, whose quality seems to suggest they went to the local 'scratcher' (a derogatory term that indicates the industry's disdain for third-rate or unregulated tattooists).

In the case of David Beckham, he is the object of such hero worship that thousands of people, wanting to have a piece of him, have paid to have an identical back tattoo to his. This is a thornier issue: if we like a tattoo we see on someone else, should we be entitled to replicate custom work? In theory, perhaps, people should be free to get anything they want. The ethical question is whether a tattoo artist should copy, line for line, someone else's work to please a client. And does the concept of an imitation tattoo not obliterate the very individuality that the tattoo industry prides itself on?

Perhaps we should take a moment to distinguish between custom work and so-called 'flash', for therein lies a world of difference.

Apart from basic flash designs which have not been customized, anything that does not derive from flash, or is copied from other existing artwork, is custom work. That means that someone has had a particular idea and got their tattoo artist to turn it into a unique, bespoke design which, if well executed, perfectly fits their own body.

Opposite: David Beckham, one of the most famous sportsmen in the world, and one of the most high-profile tattooed celebrities, does not shy away from showing his tattoos in public. Most of his ink work is designed and tattooed by Louis Molloy, from Middleton, UK, who has also tattooed Victoria Beckham

Right: An example of a sheet of flash which depicts different visual representations of stars, from the extremely stylized to the more figurative

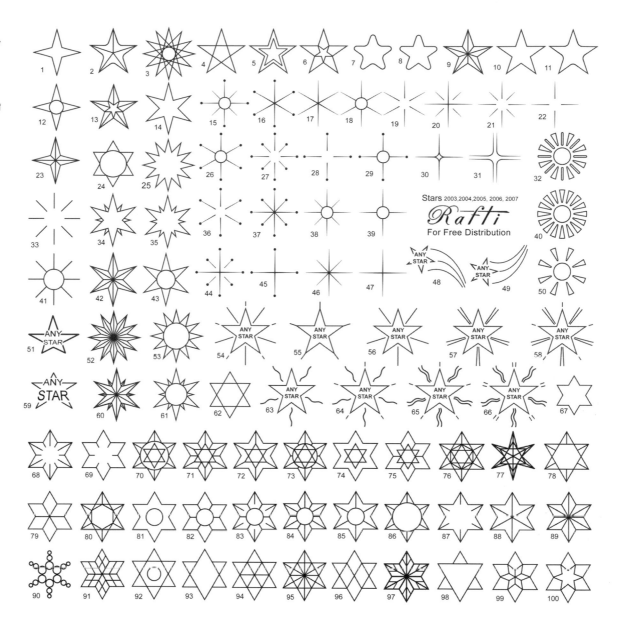

Flash, on the other hand, is any ready-to-use design which clients can choose from a book. The flash can be scaled to the size needed, and the tattoo artist can customize it. Obviously, anyone can get flash work done. Artists often produce sets of flash with dozens of designs, which they then sell around the world, so anyone can get precisely the same design.

Both forms of tattooing, custom work and flash, are highly prevalent today, but the beauty of tattooing arguably lies – just as in other forms of art – in its uniqueness, so it is perhaps rather a missed opportunity to choose something not exclusively tailored to oneself and to the contours of one's own body.

There are plenty of artists who specialize in custom work. They will not copy someone else's work, but may take suggestions if the client has been inspired by a specific tattoo

or other artwork. Some custom artists specialize in a particular style, so it is always advisable to see some of their previous work to gauge whether they can accommodate the client's needs. The fact that they design bespoke tattoos naturally involves a lot of preparatory work, research, and the laying out of stencils to fit the body. This requires time, and it pushes up the costs. As in any profession, exclusivity and quality come at a price, but the results are worth it.

Some custom tattoo artists also do what is known as 'freehand' work. Freehand indicates the direct application of the ink on the skin, without the use of stencils. Drawing directly on the customer's skin to fit the tattoo on the body part as best they can, the tattooist then moves on to the tattooing stage. It offers the client peace of mind to see the work on paper before the work on the skin begins.

But don't be fooled. Despite the beautiful works displayed on these pages, there are still plenty of tattooists producing sub-standard work. There is a huge gulf between freehand custom tattoo artists and someone who has been practising with their new tattoo gun on the skin of an orange for a week. Tattooing is a growth industry, but mostly self-regulated. As long as health and safety guidelines are observed, there is no one to decree who is good and who is not: it is up to the client to be able to tell the difference. In theory, anyone can buy a tattoo gun and start tattooing. While everyone has to start somewhere, nobody wants to be the recipient of a bad tattoo from a scratcher. Not everybody is able to tell a good tattoo from a bad one, and with a huge demand for tattoos, there is always someone caught out, whose tattoo will need 'fixing'.

Some studios have even started to provide laser tattoo removal (not of their own work, one hopes!) to customers unhappy with their tattoos. There are plenty of reasons for people wanting their tattoo removed; perhaps it was badly executed, turning it into ugly scar tissue because the skin was 'attacked' with the tattoo gun. And it's not only poor-quality tattoos: some outgrow their tattoo – or the person to whom it pays tribute; there are others whose circumstances change, meaning they cannot sport their beloved tattoo on their body part of choice because of a new job or other social situation.

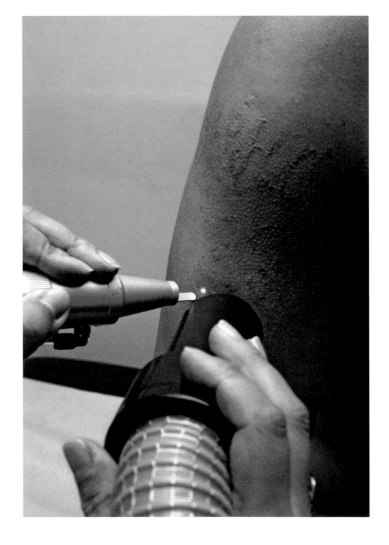

Tattoo removal using laser. This procedure is now offered by a number of tattoo studios which advise clients to remove a layer or two of pigment from an old, undesired tattoo before having it covered up with a new one

Despite the tattoo revolution of latter years, tattoos on exposed body parts are not universally accepted in the workplace.

Laser tattoo removal is a costly, pay-per-session procedure. Depending on the size of the tattoo and the type of pigments used, it will take several sittings to erase the undesired work. Each session requires several weeks' healing time. This is how it works: the laser beam hits the ink as the tattoo is retraced; the ink breaks down and is processed by the body; the tattoo appears to fade progressively after each session. As luck would have it, badly executed tattoos are often easier to remove, as the ink has not penetrated too deeply into the dermis, while more accomplished work (and certain bright pigments) can require more treatments. One drunken dare could easily become very expensive and time-consuming to fix. It is not unheard of for people to have their tattoo erased by using acids or having the layer of skin removed. Needless to say, these are drastic and invasive ways of dealing with it, and the laser option is preferable.

Laser tattoo removal, however, is not the only option. An offending tattoo can, with the help of a skilled artist, be covered up by another tattoo. A cover-up can render the tattoo underneath completely undetectable, although sometimes the old tattoo is incorporated and refined into the new work. Even when getting a cover-up, it is sometimes helpful to have a couple of laser removal treatments before the new tattoo work begins. Famously, Johnny Depp had his 'Winona forever' tattoo partially lasered off and altered to read 'Wino Forever'.

* * *

Getting your first tattoo

You've mulled it over, you've done your research, you've watched the TV shows, you've bought the magazines, you've saved your money, and now you want to get your first tattoo. What's next?

First of all ask yourself if you truly want it. Do not succumb to peer pressure, do not get a tattoo as a fashion accessory and do not get it when you are drunk. If you have a medical condition, seek specialist advice before getting a tattoo.

Once past that hurdle, possibly the most important decision about getting your first (or indeed any) tattoo is to find the right artist. There is plenty of information available in the form of online portfolios, websites, tattoo shows and publications, but make time to meet with your prospective tattooist face-to-face. You should feel comfortable explaining what you want and be wary of anyone who tries to sell you something else. If you go in for a butterfly and come out with a tribal back piece, something has gone wrong! Of course, always allow yourself the time and flexibility to take on board the suggestions of the tattooist – this artwork will stay with you forever, and laser removal will cost a lot more than the tattoo ever did.

This is also a good opportunity for you to check out the tattoo studio. Is it clean? Are you comfortable? Is there a private area available and is the tattoo area separate from the reception? Knowing that your tattooist is safe and clean is of paramount importance. Tattooists should sterilize their equipment and throw away gloves and tattoo needles after each use. New ink pots should be prepared for each client and a sterile antiseptic solution used to clean the tattoo after each application of ink.

When the work is done, your tattoo artist will give you aftercare advice. You should avoid exposing it to the sun straight away and you should apply some protective ointment on your skin. It will swell up, but will soon return to its normal size. Look after your tattoo – but above all, enjoy it!

Tattoo conventions bring together tattoo enthusiasts and artists from around the world, as well as featuring competitions and a range of entertainment. They provide an 'entry level' experience for those who are thinking of getting their first tattoo

In the UK alone, there is a tattoo convention somewhere in the country each weekend of the year. Only a few years ago, you could count on one hand the tattoo shows taking place in any given year. Promoters have realized that tattoos are good business, and now we are spoilt for choice. In 2010, the Berlin tattoo convention, one of the pioneers of the scene, turned the grand old age of 20. The organizers celebrated by hiring a disused city airport hall and filling it with tattooists, merchandizing stalls, an art exhibition and plenty of entertainment for all ages. Tattoo shows are no longer the grimy biker dens they once were: they are family-friendly occasions, in some cases even offering crèches. These conventions attract tattoo artists from around the world, and provide a bridge to those artists many punters would not otherwise get access to. Visitors do not necessarily go in order to get tattooed, although plenty do. It's an opportunity to soak up the atmosphere, to watch tattoo artists work, have a drink, socialize, see some art, enjoy performances and indulge in a spot of shopping as there is usually plenty of merchandise, from books to clothing to original artwork. It's a fun day out and certainly not dull. These shows have greatly contributed to the popularization of the genre, attracting thousands of visitors, allowing people to meet artists and like-minded

devotees, showcasing artists' work and educating an audience who can watch and learn without the pressure of getting tattooed there and then.

It is partly the influence of these conventions, as well as celebrity endorsements and television coverage, that has turned a few class artists into tattoo superstars. In some cases their reputation springs entirely from the quality and craftsmanship of their work, word spreading faster these days in our global community. We have already seen the meteoric rise to fame of Kat Von D, and in the pages that follow we dedicate feature pages to some of the biggest and best tattoo artists in the world today. While rock stars are more overtly manufactured and sanitized than before, tattoo artists have taken their place as the new rock stars. The success of tattoo conventions, the proliferation of tattoo magazines and tattoo-inspired clothing and merchandise have all contributed to draw attention to the stars of this show: the artists themselves. With devotees who travel from afar to see them work as if on a secular pilgrimage, with girls (and boys) vying for their attention, with their work being collected on human canvases, and often with a truly decadent lifestyle, tattooists have easily taken over the role of rebels which once belonged to rockers. The archetypal tattoo artist working in a dingy seaport shop has given way to a globe-trotting artist who can and will travel anywhere with their trusted tattoo kit, with no ties and artistically free.

But travel though they may, the tattoo artist's natural domain is his or her traditional tattoo shop. It's laden with ritual and with a certain thrill; for some, a sanctuary from the formulaic world, for others, an arcane adrenaline den. In this respect, the studio mirrors the multifarious facets of the tattoo itself: from its roots in solemn rituals and social rites, tattoo has undergone numberless manifestations and transformations to become what it is today. In recent years tattoos have even been applied in a reconstructive function, administered after major surgery such as mastectomies or to restore skin discoloration in conditions such as vitiligo. The psychological benefits of such work are immeasurable, and it is an aspect of tattooing which deserves much more publicity. At least, however, a true representation of this extraordinary industry is for the first time visible to the general public. Its rich history – chequered and seductive in equal measure – is a tradition in which to take pride, a vast, global community that brings with it a sense of belonging. Whether to beautify, decorate, shock or commemorate, the act of the tattoo remains always a ritual, and one that always begins in the humble tattoo shop. The ceremonial quality of visiting this little temple to body art, acquiring a memento which will accompany us for the rest of our life, is one of the reasons why this is all so fascinating. And one of the reasons we might even go back for more.

DORALBA PICERNO

The Japanese tradition

Japanese tattoos are surprisingly well-known to Western eyes. As the power of the internet ceaselessly expands and we move towards a global society, Japanese tattooing conventions are less of an arcane event than they used to be. The genre of Japanese tattoos runs the whole gamut from Kanji script to the age-old motifs that are stylistically influenced by traditional wood block prints. For the uninitiated, Kanji is one of three writing systems in Japan, in which abstract symbols are used to communicate.

Japanese masters have travelled to tattoo shows in the West and divulged the finer points of their art, books have been published on the subject, and a few Western tattoo artists have actually completed much sought-after and rare apprenticeships with Japanese tattoo masters, after which they have come back to spread the word. Despite its undoubted influence on Western practice, Japanese tattooing is still regarded with some suspicion in mainstream Japanese society. People who display their skin decorations can struggle to rent an apartment or secure a job – even being admitted to a public swimming pool can be problematic.

This is, of course, the same society where entire tattoo body suits are closely associated with the *yakuza*, the Japanese organized crime network, whose members (and often their partners) are renowned for their extensive tattoo work marking their affiliation to a specific gang. These tattoos are revealed to other gang members in ritualistic ceremonies or at tattoo festivals, but otherwise tend to be covered up by clothing, as they are considered a private endeavour, not to be shared with strangers. The *yakuza* tattoo tradition dates back to the era of the Shoguns, when criminals would be marked with crude ring tattoos signifying their status and convictions. The subsequent adoption of tattooing as a sign of belonging underlines their refusal to abide by the rules and conform to society.

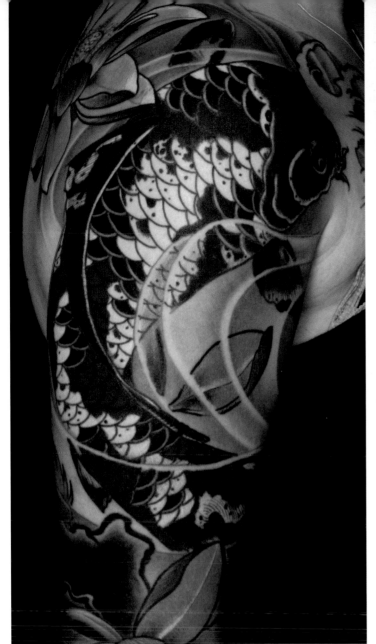

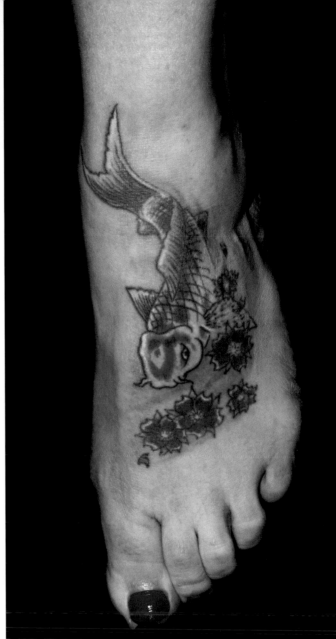

A colourful Koi carp, one of the most beloved Japanese tattoo motifs which symbolizes ambition, success and courage. *Tattoo by Richard Pinch*

Tattoo by Derek Campbell

Speaking the language

As Japanese-style art has continued to boom in the West, a number of related tattoo terms have begun to cross over into our own body art lexicon. Translated below is some basic terminology from the Japanese world of tattoo.

Horimono *a traditional Japanese tattoo*

Horishi *a traditional tattoo artist*

Sumi *ink used to tattoo, usually mixed by an apprentice*

Irezumi *literally 'to insert ink'*

Hikae *chest tattoo*

Nagasode *whole arm sleeve*

Sujibori *the outline of a tattoo*

Tebori *tattooing by hand (without electric machines)*

Yakuza *members of organized crime syndicates in Japan, often marked out by their full-body irezumi tattoos*

★ TRAILBLAZERS

Filip Leu

It is a name synonymous with high-quality, large-scale custom work. Filip Leu, son of Felix (a legendary tattoo artist in his own right) is a Swiss artist based in Lausanne who is very well-known for his outstanding Japanese-style work, although his output is not limited to that alone.

Filip had a Bohemian upbringing as the son of two travelling hippie artists. Exposed to different cultures and art forms from an early age, he started tattooing full-time as a teenager, completing at the tender age of seventeen a grand tour which helped him to refine his skills and learn tattoo techniques from masters around the world.

His work is highly sought-after and exquisite, and it is at its best when covering a large canvas. He has been instrumental in introducing rotary machines that use more needles than standard models, allowing him to complete large shaded areas with apparent ease and enabling him to work faster and produce large pieces with the dexterity of a painter using a large paintbrush.

Filip Leu travels to a few select tattoo conventions a year, where he is usually mobbed by adoring fans; for the rest of the year, he works regularly from his studio in Lausanne.

He is a tattooist's tattooist, the artist of choice for other tattoo artists looking to get inked. Many of them are friends: Filip Leu has always been willing to co-operate with other artists, an attitude which led him to create, in 2000, the Art Fusion experiment with fellow artist Paul Booth (see page 108).

This project, later joined by artists Bernie Luther, Guy Aitchison and Sean Vasquez, is now so popular that it has become a staple of major tattoo shows. It involves four or five artists drawing with charcoals on individual canvases for a few minutes at a time, and then swapping over until all artists have worked on all canvases. The results are a wonderful fusion of styles and creative inputs. These collaborations always draw large crowds and the resulting pieces always succeed in blurring the boundaries between low-brow and fine art. Over the years, some of the canvases have been exhibited and others auctioned off for charity, while the artists enjoy the mutual inspiration they are able to share with one another.

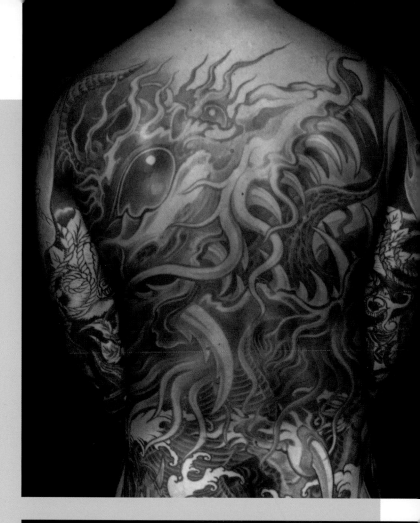

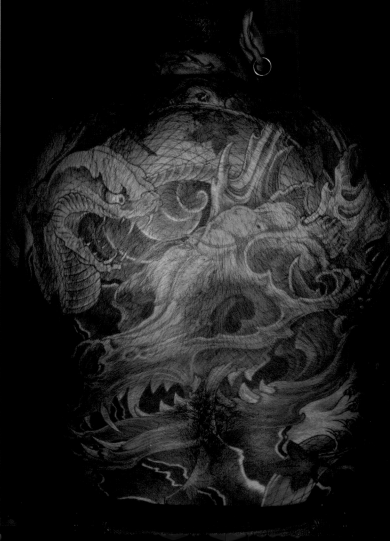

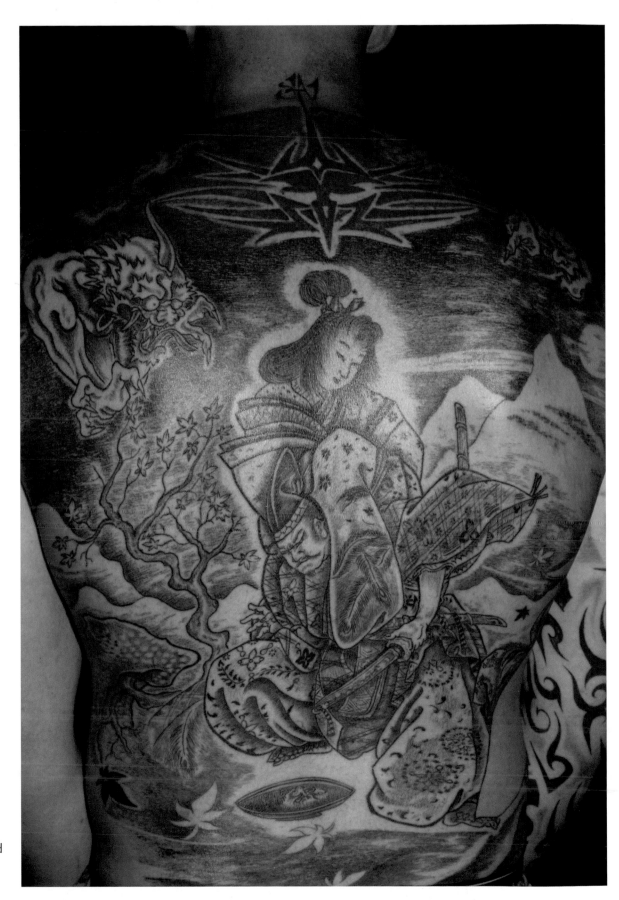

An example of a Japanese-themed tattoo entirely executed with tattoo sticks (*by on-the-road artist Lard Yao*)

Japanese symbols

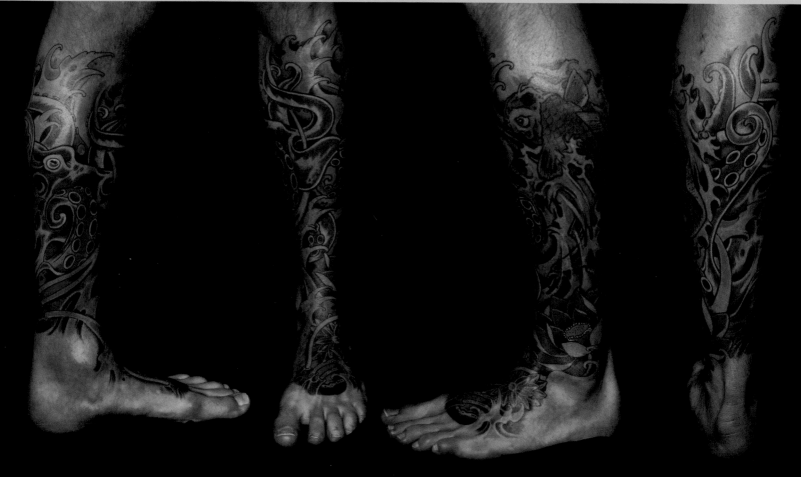

Koi: The koi fish — or carp — is an extremely popular tattoo motif. The dazzlingly coloured fish, prized by private collectors around the world, originates from China. This animal is invested with the heroic qualities associated too with the most popular Japanese icon, the samurai warrior. As it swims up waterfalls, with the mythological promise that if it gets to the top it will be turned into a dragon, the koi is a powerful symbol of success, ambition and courage for attempting to flourish against the odds. *Tattoo by Scott Hensler, Kingston Ink, Portsmouth*

Hannya (or hanya): The best-known of the Noh masks (used to portray female or non-human characters in Noh theatre, a traditional musical drama genre), Hannya represents a deranged woman who was once in love with a priest. Her unrequited love and insane jealousy drove her mad and she is forever disfigured by her rage and sadness. Her horned features are said to ward off evil spirits, protecting those who wear her face. *Tattoo by Skin Factory, Bonn, Germany*

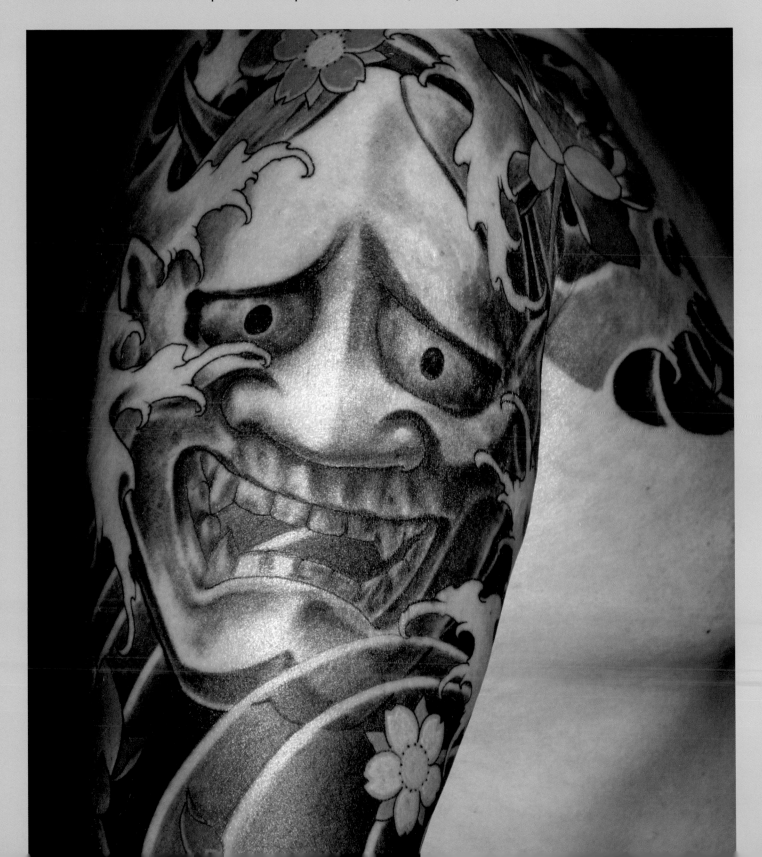

Dragon: Although dragons are popular in Western myths, it is Japanese dragons that abound in tattoo imagery, mostly due to the great legacy of Japanese tattoo styles, which are so widely influential and admired. Japanese dragons have a snake-like body, clawed feet with three toes, and no wings, as they are water deities. As such, they are believed to control water in the form of rain or floods. Their depiction is heavily influenced by that of the five-toed Chinese dragon, as native folklore has mixed, over the centuries, with legends from nearby countries such as Korea, China and even the Indian subcontinent. Of the many meanings attached to dragon imagery, the most common are protection of home and family, longevity and power. But the symbolism is also heavily dictated by the context and scene within the tableau. For instance, if a dragon and a tiger are depicted together, the tattoo takes on symbolic meanings based on the relationship they appear to have: if they are at an equal level, they represent Yin and Yang; if the dragon is overpowering the tiger, it connotes a victory over dark forces, and so on.

The meaning of the Chinese dragon is slightly different, and it is defined by many factors which affect its physical representation. *Tattoo by Marco Bratt, Noordwieg, Holland*

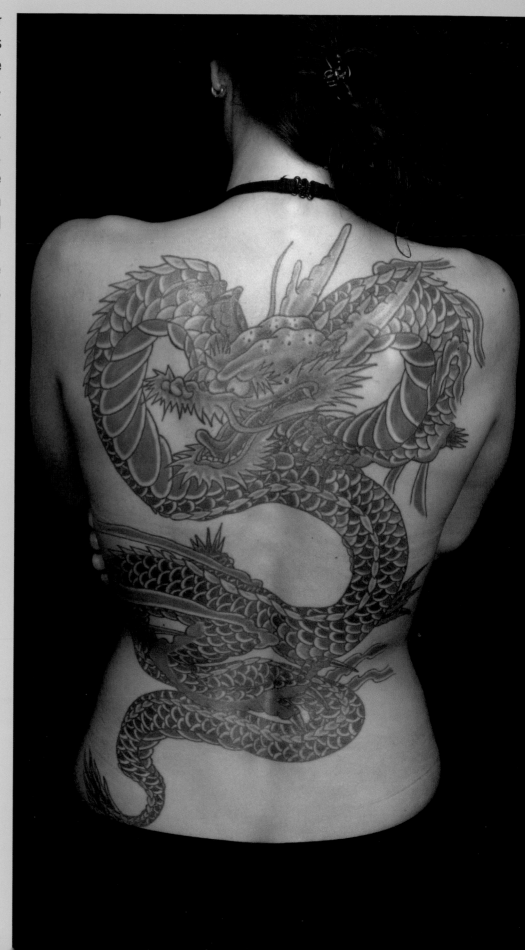

Cherry blossom: A celebrated ritual in Japan is cherry blossom week, when the fast life-cycle of the cherry-tree blossoms comes to symbolize our life in all its fragility, serving as a reminder to make the best of our time on earth. Perhaps unfairly, cherry blossom motifs are often used as backdrop decoration for larger pieces featuring other main symbols such as geishas, which are considered a feminine motif. Japanese cherry blossom holds a different meaning to its Chinese counterpart, which is intended as a symbol of the powerful feminine, rather than the transience of life. *Tattoo by Matt Beckerich, King's Avenue Tattoo, New York, USA*

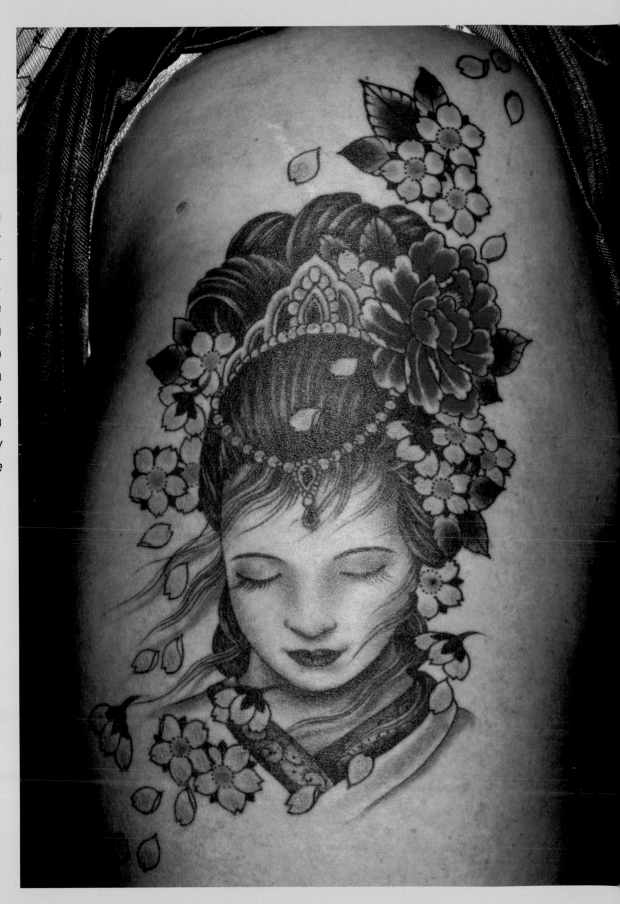

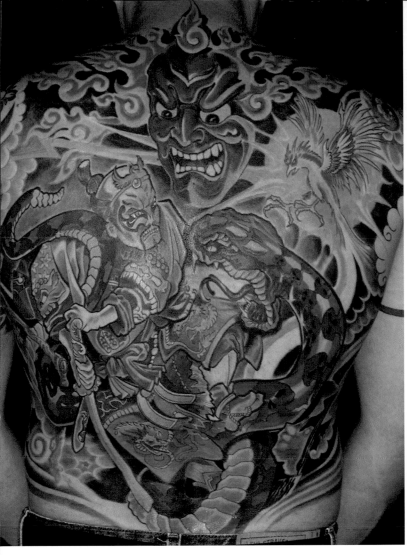

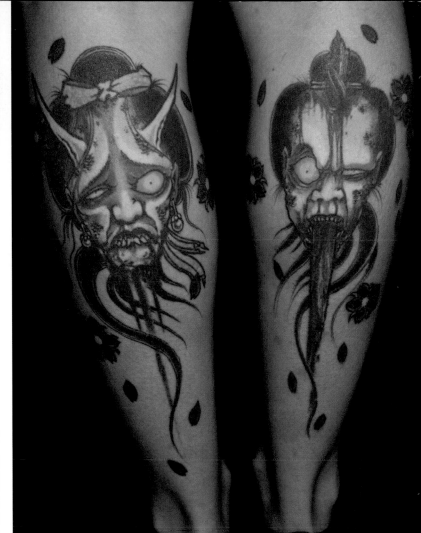

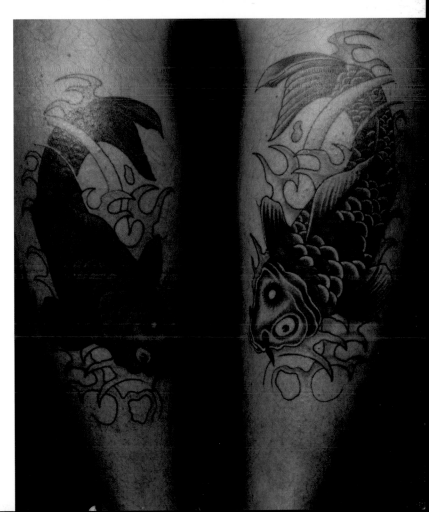

Opposite and above: Tattoos depicting traditional and mythological Japanese imagery are popular in the East and West alike. *Tattoos by Leo, Naked Trust, Salzburg, Austria*

Top right: Two grotesque representations of Hannya (see page 27), here surrounded by cherry blossom petals. *Tattoo by Martin Mon, on the road artist*

Right: A wry take on the koi fish motif. *Tattoos by Urban Image*

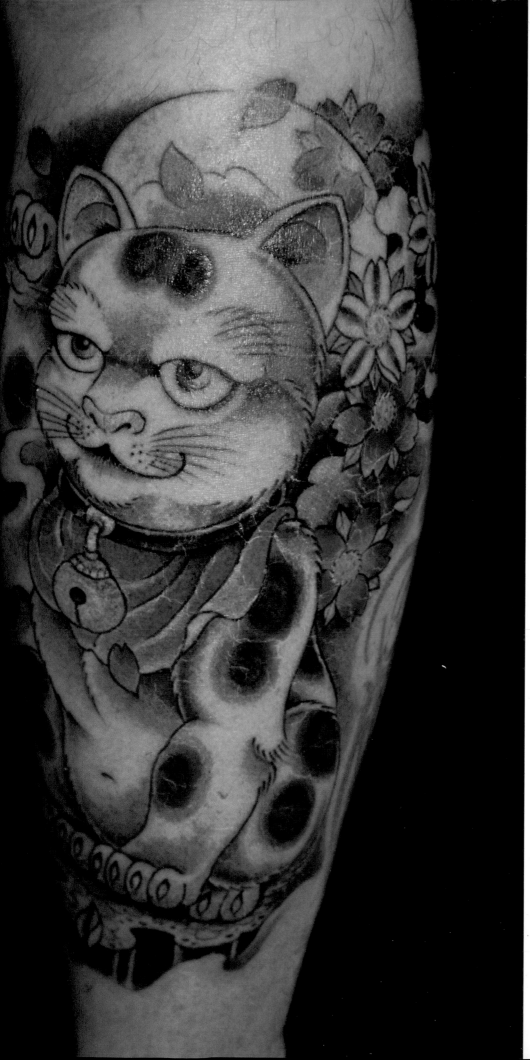

A 'Maneki Neko', also known as 'Money Cat' or 'Welcome Cat', a sculpture of a cat with a lifted paw which brings luck to its owner and is often found at the entrance of shops, restaurants and other such businesses. *Tattoo by Salvio, Psycho Tattoo, Rome, Italy*

★ TRAILBLAZERS
The Japanese Elite

Horiyoshi III

Horiyoshi III (real name Yoshihito Nakano) is possibly the best-known living Japanese tattoo artist in the world and no tattoo book would be complete without a special mention of his exceptional work. Horiyoshi III is a traditional tattoo artist, also known as *horishi,* who specializes in full-body custom tattoo work.

The prefix 'Hori', which forms the first part of many Japanese artists' names, roughly translates as 'to carve' — a reference to the original tattooing implement of sharpened bamboo that was used to push ink into the skin. And indeed, Horiyoshi III still uses bamboo tools when colouring in the tattoos, although he uses a traditional rotary machine for the outlines. 'Hori' is more than a mere title though: it is a way of life. It indicates that the artist has a deep knowledge of the history and meaning of Japanese tattooing, and that he or she specializes in that kind of work alone.

Traditionally, a 'Hori' name should be inherited from the master who has trained you, although nowadays the rules are not so stringent and in theory anyone can use a 'Hori' name, so it pays to do your research if you are looking for a classically trained tattoo master. Upon his retirement in 1971, the old master Horiyoshi I passed on his Hori-name to both his son (who became Horiyoshi II), and his star apprentice, Horiyoshi III, marking his passage from pupil to master tattooist. Horiyoshi III's own son will follow in the tradition and will eventually assume the name Horiyoshi IV.

As one of the first Japanese tattoo artists who travelled the world and appeared at tattoo conventions, Horiyoshi III almost single-handedly popularized Japanese tattoo work in the West. In the 1980s, in a successful blend of Japanese tattoo traditions and Western techniques, he started using electric machines in his work, allowing him to explore more creative possibilities while keeping intact his traditional repertoire.

He is also the founder of a tattoo museum in Yokohama, the city where he lives and works, providing a space for a deeper understanding of tattoo art and its symbols as part of Japanese culture, bridging the gap between the old-school tattoo masters and the younger generation of well-travelled *horishi* artists. Horiyoshi III has also recently lent his name to a line of limited edition, luxury tattoo-inspired leisurewear made in Japan. His collection uses his elegant tattoo designs and the full gamut of the tattoo symbols of which he is a master, ranging from Japanese folklore to mythology, and translating his designs into three-dimensional art for the first time ever in the form of jewellery.

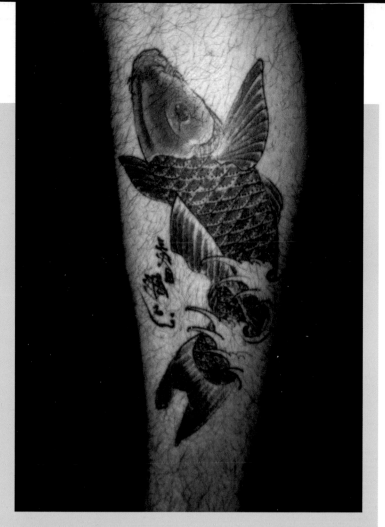

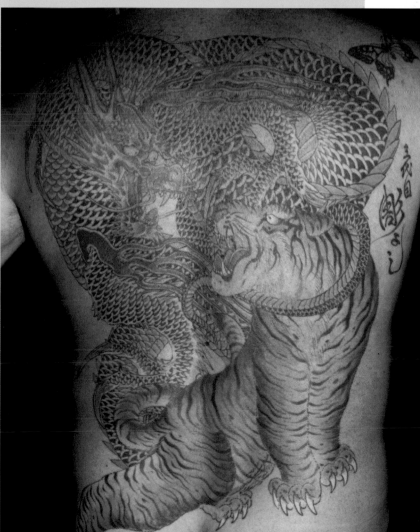

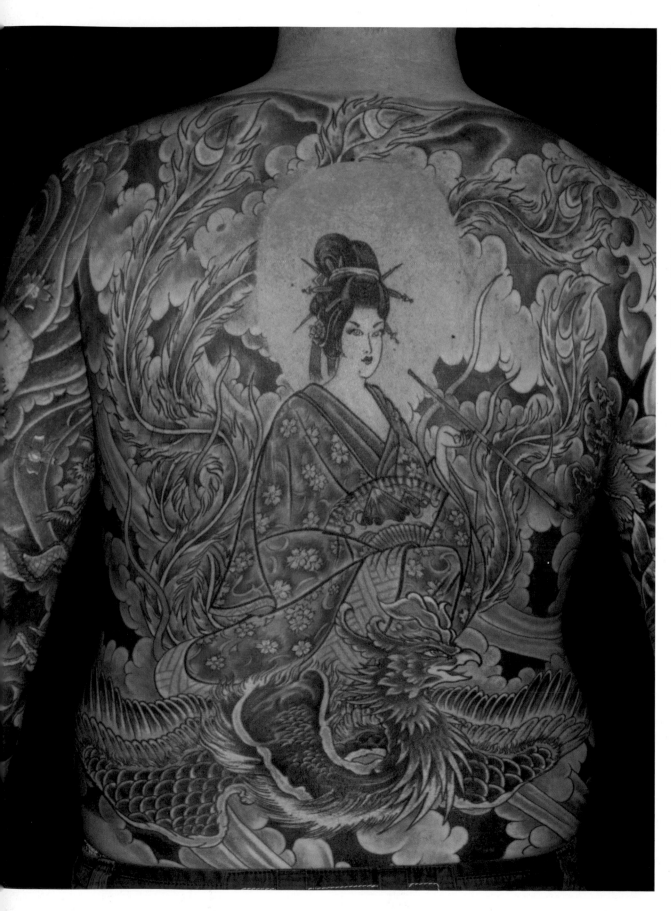

Left: A traditional geisha atop a phoenix in this striking full-colour back piece. *Tattoo by Derek Campbell*

Opposite: Pictured here are three major subjects of Japanese iconography: right, a phoenix (*tattoo by Takami*); top far right, a dragon surrounded by a cloud of smoke from which a Hannya mask is emerging (*tattoo by Lemme, Potsdam, Germany*); and bottom far right, a black and grey representation of a samurai warrior on his horse (*tattoo by Marcuse, Smilin' Demons, Mannheim, Germany*)

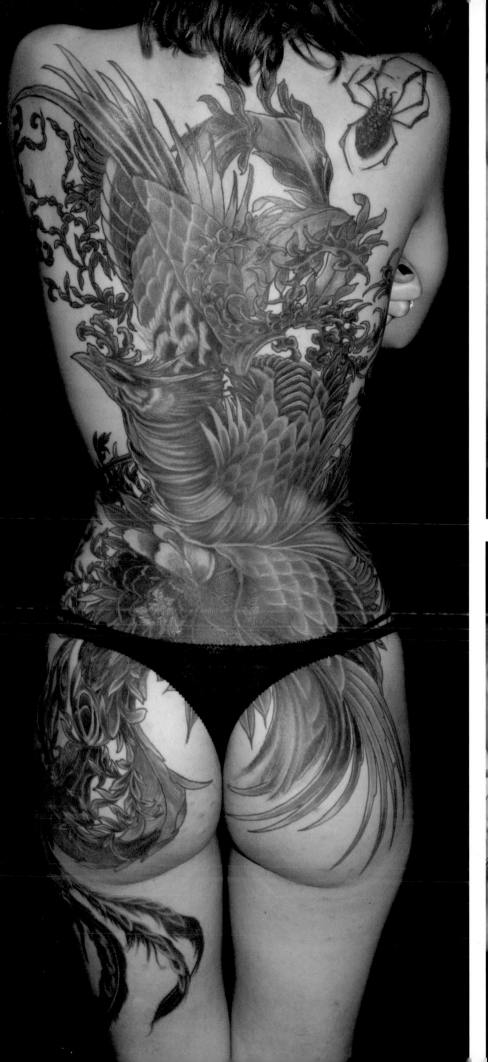
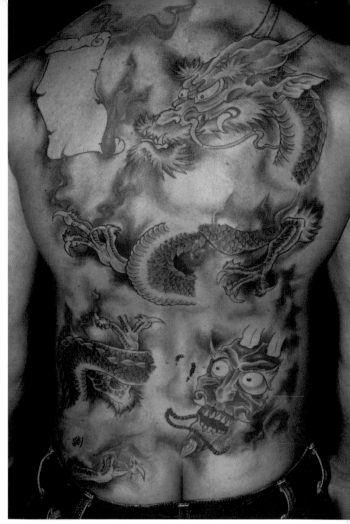
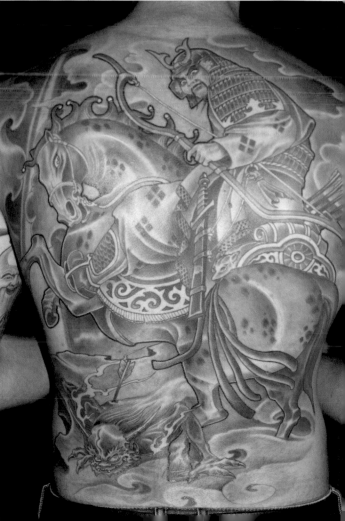

Going tribal

Once incredibly popular, tribal tattoo work has now settled into a niche, superseded by trendy colour work. It has not, however, lost its appeal: if anything, going back to basics has allowed the genre to rediscover its roots and become more ethnically grounded than in the 1980s and 1990s, when it became so ubiquitous that it rather lost its way.

Modern tattooing came about with the discovery of Polynesian tribal practices by Western seafarers in the 18th century. The ornate designs on the tribespeople's bodies must have seemed incredibly striking. The sailors carried the idea home and Western tattoo culture was thus born, but it was not until the 1980s that large-scale tribal tattoos made their appearance, their thick bold lines and elegant patterns imbued with meaning, often depicting highly stylized interpretations of universal icons like the Sun, God and Man. Though the designs were traditionally rendered in black ink, areas of skin left blank were equally important in order to create a balance on the body.

The popularity of these designs flourished so widely in the West that they grew somewhat hackneyed and all but disappeared. But a few years out of the spotlight have allowed a new generation of well-travelled tattoo artists to emerge who are able to create meaningful work incorporating world cultures, Western sensibilities and new tattoo techniques: a New Tribalism of sorts. The designs are as diverse as the cultures that spawned them, ranging from Polynesian to Native North American, from Maori to Mayan, from Samoan to Egyptian, from Inuit to Pagan, from Haida to the tribal peoples of Borneo and beyond.

Often associated with tribal work, and also extremely popular in the 1980s and 1990s, is Celtic tattoo art. Although the culture is deeply rooted in the British Isles, the Celts actually spread all over Europe and parts of Asia. The symbols usually appropriated for tattoos originate from ornate monastic manuscripts (mostly translations of Christian texts), and incorporate intricate interwoven knotwork patterns of animals such as dragons, dogs, serpents and peacocks.

The Triquetra, a triangular eternal knot, is believed to symbolize the circle of life, although it was appropriated in Christian books bearing Celtic decorations because of its obvious connection to the Holy Trinity. More recently, it has been reclaimed by Wiccan cults where it represents 'the power of three'.

A beautiful Celtic tattoo by Bugs, an artist who was very influential in the genre in the early 1990s (see page 13 for more of his artwork). The introduction of colour reversal in grey between the main large motifs in black and grey was particularly innovative (visible here on the knee area).

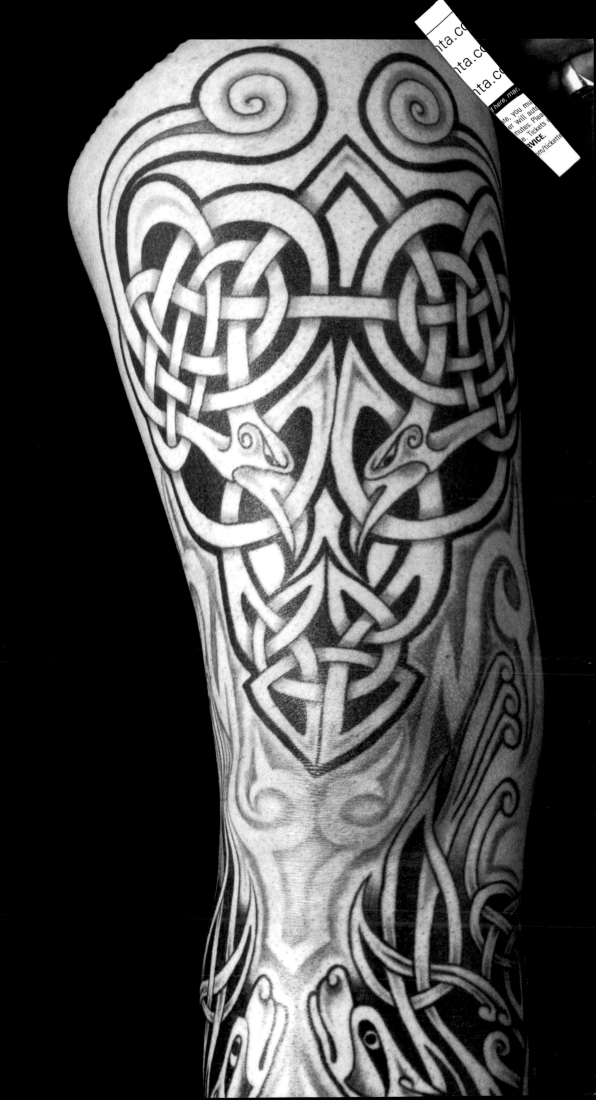

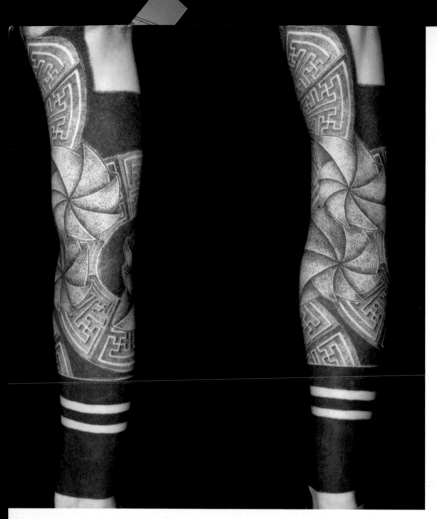

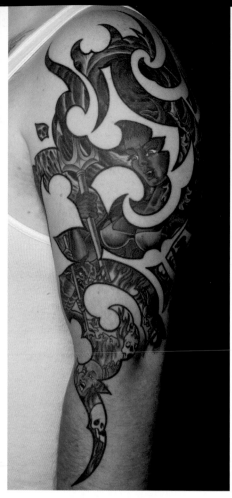

Far left: *Tattoo by Adam Sage, Temple Tatu, Brighton, UK*
Left: *Tattoo by Scott Duncan, Ontario, Canada*
Below: *Tattoo by Troy Bond*

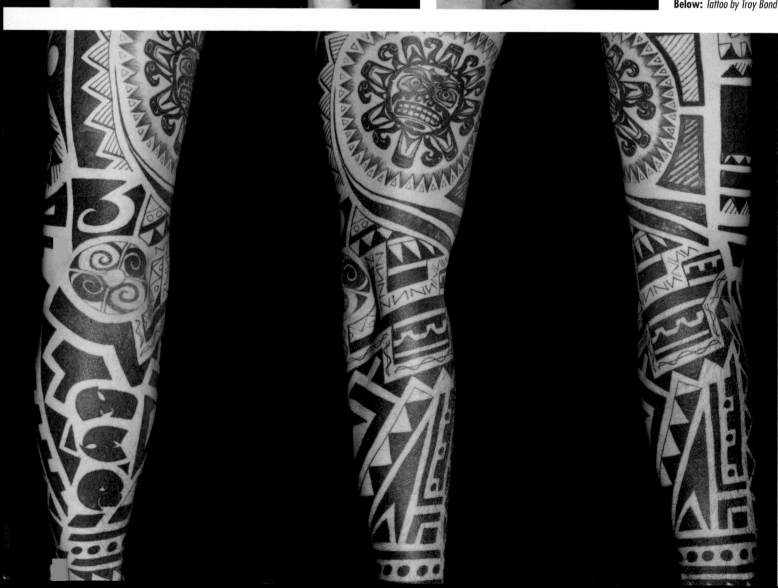

These tattoos show the range and scope that tribal work has achieved in the last 30 years.

Above: an intricate Aztec tattoo (*by Kirdyk, Studio Artefact, St Petersburg*).
Far right: a tattoo which incorporates optical illusion abstract design (*by Beautiful Freak, Belgium*).
Right: a colour Celtic-style tattoo (*by Toby, Asgart Tattoo, Neustadt, Germany*).

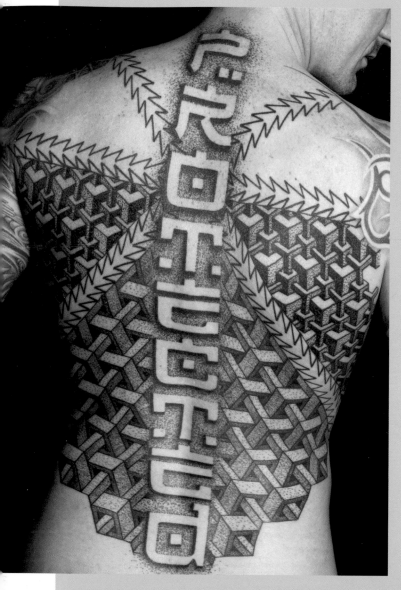

★ TRAILBLAZERS
Xed LeHead

Initially inspired and encouraged by Alex Binnie (see page 47), Xed LeHead has become one of those artists whose style has been acclaimed and imitated the world over. His elegant geometric dot work was born of a need to fill spaces, and has evolved into the creation of light, intricate and aesthetically stunning designs that allow even large pieces to sit on the body without weighing it down with heavy coverage.

Xed's interest in geometric and recurring patterns in nature has enabled him to create a style which, although at times purely decorative, reveals a deep understanding of the world around us and our place within it. His work is effortlessly at one with the body that wears it, the layers of dots lending the work a spiritual quality absolutely in keeping with the unmistakable Far Eastern influence in his designs.

Typically self-deprecating, Xed alleges that his style emerged from a lack of drawing ability, although one needs only to look at his works to recognize his acute sensibility and understanding of the human form, as well as his capacity to connect with clients which results in unique, tailored pieces.

After producing tattoos by hand for a while, coupling the spirituality of his work with the almost meditative manual tattoo experience (see page 44–5), Xed opted for rotary machines and has been using them for some years. He still manages to reach a spiritual plateau while tattooing, and the machine allows him to work faster, which he prefers.

Having become the master of intricate and elegant dot work has not stopped Xed from taking up extreme challenges such as tattooing the infamous Lucky Diamond Rich black, essentially filling in the gaps that were still remaining on his body and helping him to become the most tattooed man on earth (see page 121).

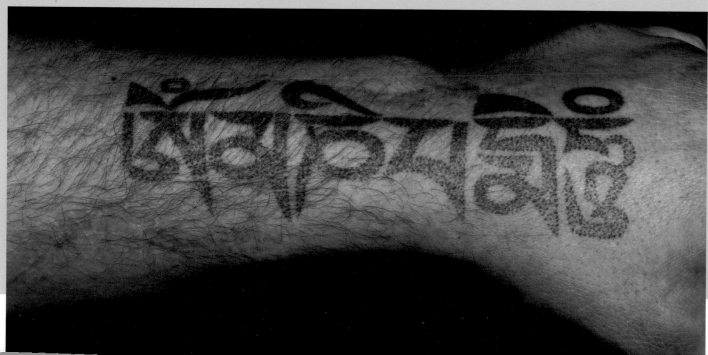

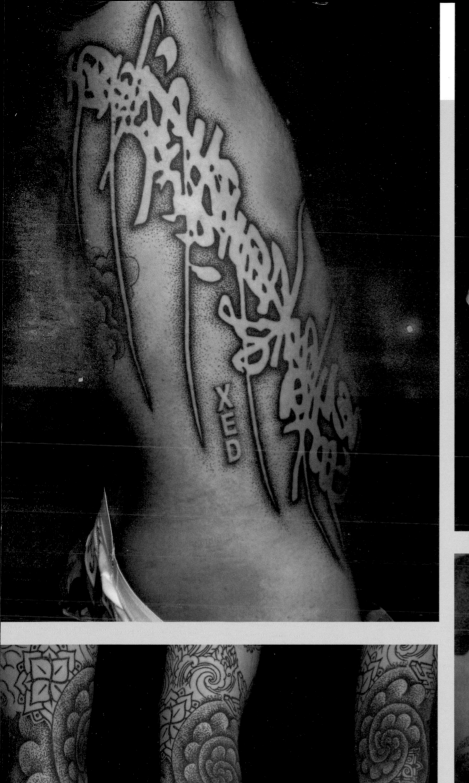
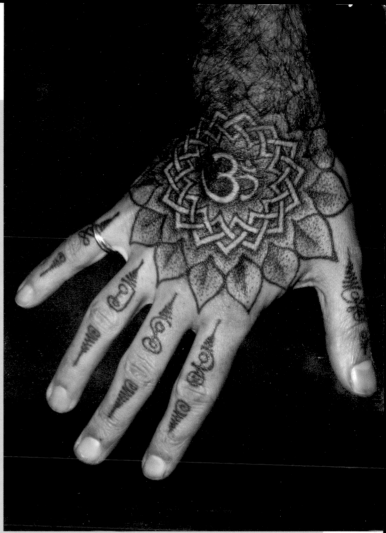
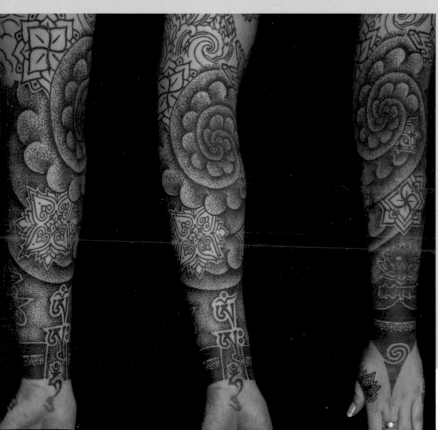
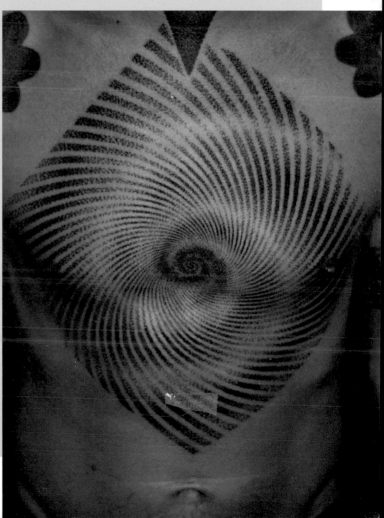

Manual tattoos
(hand tapping and hand poking)

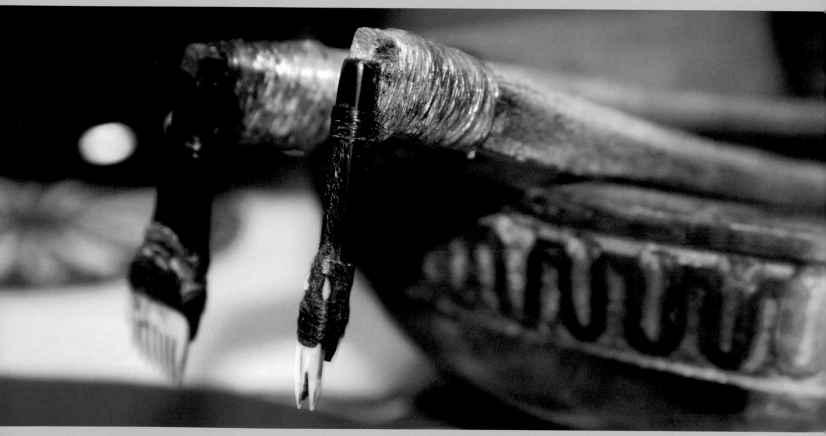

Manual tattoos are usually created without using modern machines. The only implements involved are traditional tools that have remained unchanged for centuries, using techniques learnt from tattoo masters specializing in tribal tattoo art. There are two distinct methods of manual tattooing that we will cover here: hand-tapping and hand-poking.

Receiving a tattoo by hand-tapping is generally recognized as a very spiritual experience, partly because of the ritualistic nature of this method and partly because of the human interaction involved. The process of hand-tapping involves two sticks, one of which bears the needles (this stick is called the comb), while the other is used to tap the comb

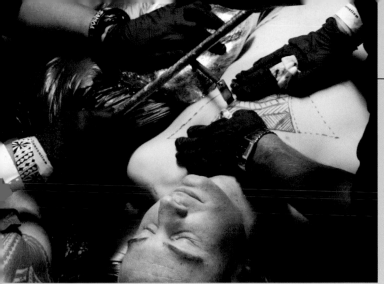
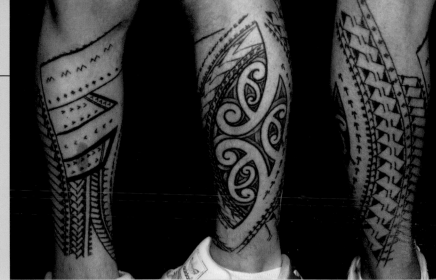

Above: *hand tapped tattoo by Brent McKeown*

towards the skin so that the needles can break the epidermis, allowing the ink to reach the dermis (this tool is known as the club).

There is also an assistant or two (called 'stretchers') whose role is to hold and stretch the skin to the desired tautness for the artist to be able to tattoo the design under the best conditions. Unlike conventional machine tattooing, both hands of the artist are engaged while hand-tapping, and help is therefore needed to tauten the skin.

With the ritualistic tapping sound and the careful attention paid to the needs and demands of the body, hand-tapping is a veritable holistic experience. There is no loud machine whirring, only the noise of one stick tapping gently on to the other, allowing for a trance-like, meditative state. The tapping technique causes less trauma to the area than machine work, and it heals a lot quicker too. In a way, the resulting work is the product of a team effort, as the stretchers have a deep knowledge of the tattoo process and help steady the surface being used as a canvas. They also help the client to relax, their holding task as much a calming human presence as a precious support for the artist.

Far from being a primitive practice producing unrefined tattoos, this is a very sophisticated technique whose roots lie in Polynesian tradition. The combs are usually handmade by the artist, who chooses the appropriate needles (depending on whether they will used for outlining or shading) and uses his or her own judgment to apply the right amount of pressure. If the tattoo is quite complicated and requires different finishes, a few combs with a varying number of needles will be used. The end result depends as much on technique as it does on the all-important dialogue between tattoo artist and client.

Another technique for tattoos which does not involve machines is the rather unfortunately nicknamed 'stick'n'poke' method. The tool used is a long bamboo stick with ink-dipped needles at one end, and it is guided into the skin by the free hand, while the other pushes the tool towards the dermis in a quick succession of pokes. At its most sophisticated, this method is used by Japanese and Thai masters, although there are artists who use pen-like tools with fewer needles as poking devices. These techniques are passed on by tattoo masters to their apprentices, who continue the tradition after many years of training. Hand-poking tattoos have now reached such popularity in the West that quite recently a tattoo convention was exclusively dedicated to artists who specialize in this form of manual tattoo.

In Japan the technique is called *tebori*, with some Japanese tattoo masters using machines for the outlines, retaining the poking technique for the shading only. The advantage *tebori* has over machine tattooing is that it allows the artist to achieve more subtle colour gradations, which over the years blend into each other to create a very natural shading effect. The disadvantage, of course, is that it takes far longer to complete.

Above: A close-up of an intricate dot work back piece. *Tattoo by Tomas, Into U, London, UK*

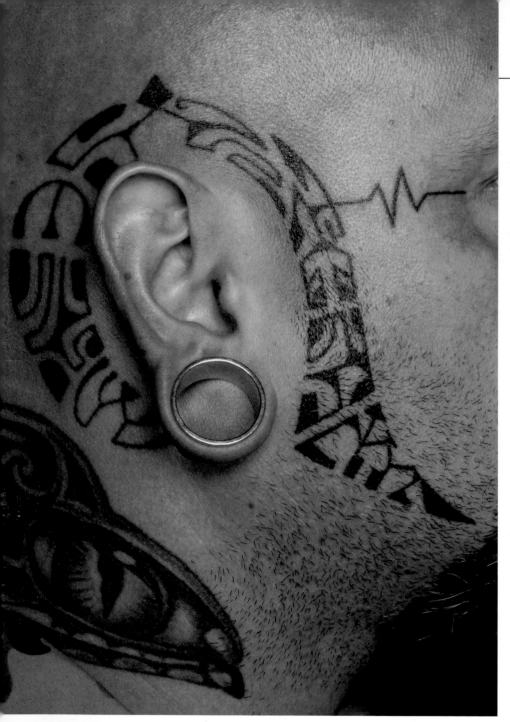

Left: A discreet face tattoo which surrounds the ear like a tribal sideburn. *Tattoo by Kristo, Canary Tattoo, Gran Canaria*

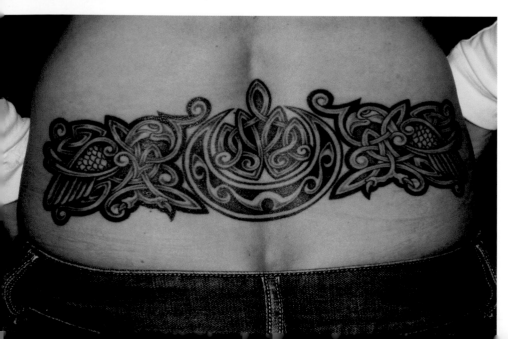

Right: A Celtic-inspired design which adorns the lower back. *Tattoo by Emi, Devils Right Hand, Vienna*

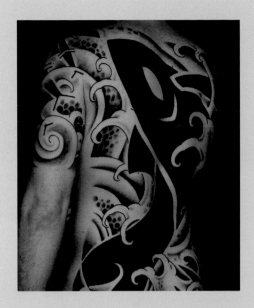

★ TRAILBLAZERS
Alex Binnie

Co-founder of the renowned Into You custom tattoo shops in London and Brighton, Alex Binnie is a world-class tattoo artist. While he has tackled several genres over the years, he has avoided being pigeon-holed in any particular category, although, as we see here, he has produced an impressive and influential body of work using large-scale tribal tattoo designs. His background in fine art and his early experience as a medical illustrator have given Binnie a unique insight and understanding of the human body: his pieces are always beautifully tailored to embrace the body and follow the muscles' contours organically.

Starting in the 1980s, Binnie was able to pioneer certain styles and techniques in the West. His trademark bold designs were news to the tattoo world, and he was able to take inspiration from tribal designs which had seldom been seen, unless you were well-travelled and had access to rare tattoo or ethnological books. Nowadays, with the wealth of information available via the internet, as well as TV shows, tattoo conventions and books, such access is widely available; back then, anyone interested in Polynesian or Marquesian tribal designs had to devote a good deal of time to researching them.

Binnie's importance on the tattoo scene cannot be underestimated. As well as being an innovative artist who has pushed the boundaries of traditional tribal work, incorporating left-field ideas and allowing different genres to meet and mingle in his work, he has demonstrated a discerning eye for tattoo talent. Over the years his shop in London has nurtured a number of amazing tattoo artists, many of whom, on flying the nest, have established very successful studios of their own: Dan Gold, Xed LeHead, Nikole Lowe, Mr X, Jason Saga and Curly, to name but a few.

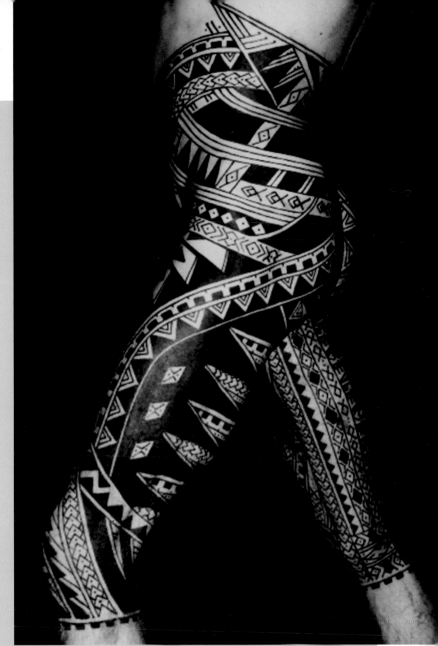

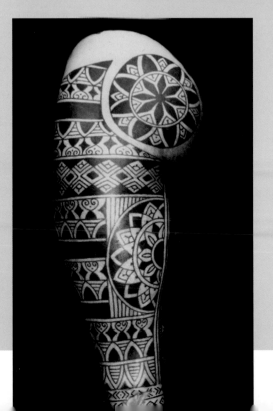

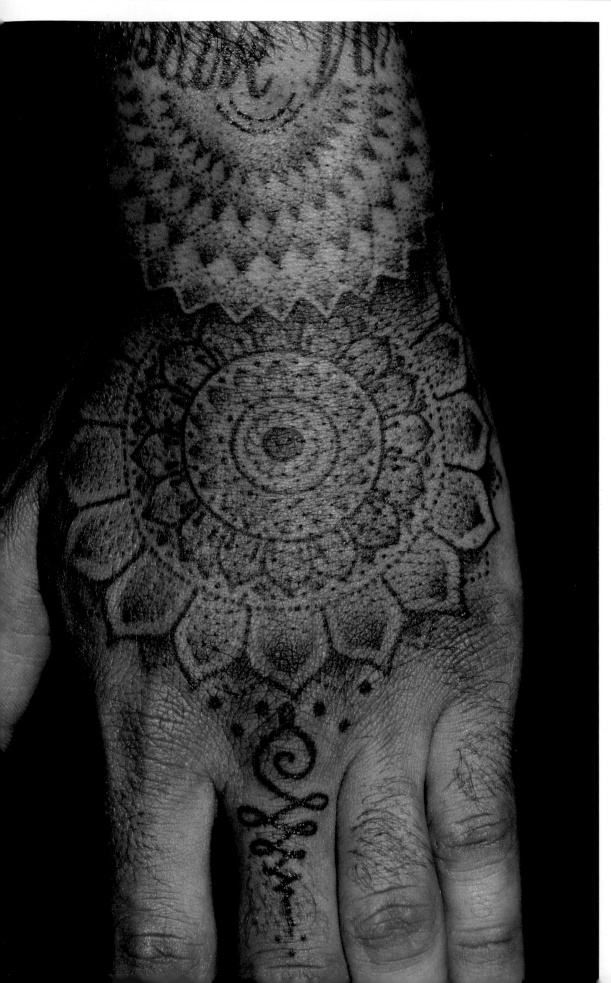

Left: A beautifully nuanced hand tattoo (*by Jondix, LTW, Barcelona, Spain*)
Opposite: Award-winning tattoo art done using manual tattoo techniques (*by Lard Yao, on the road artist*)

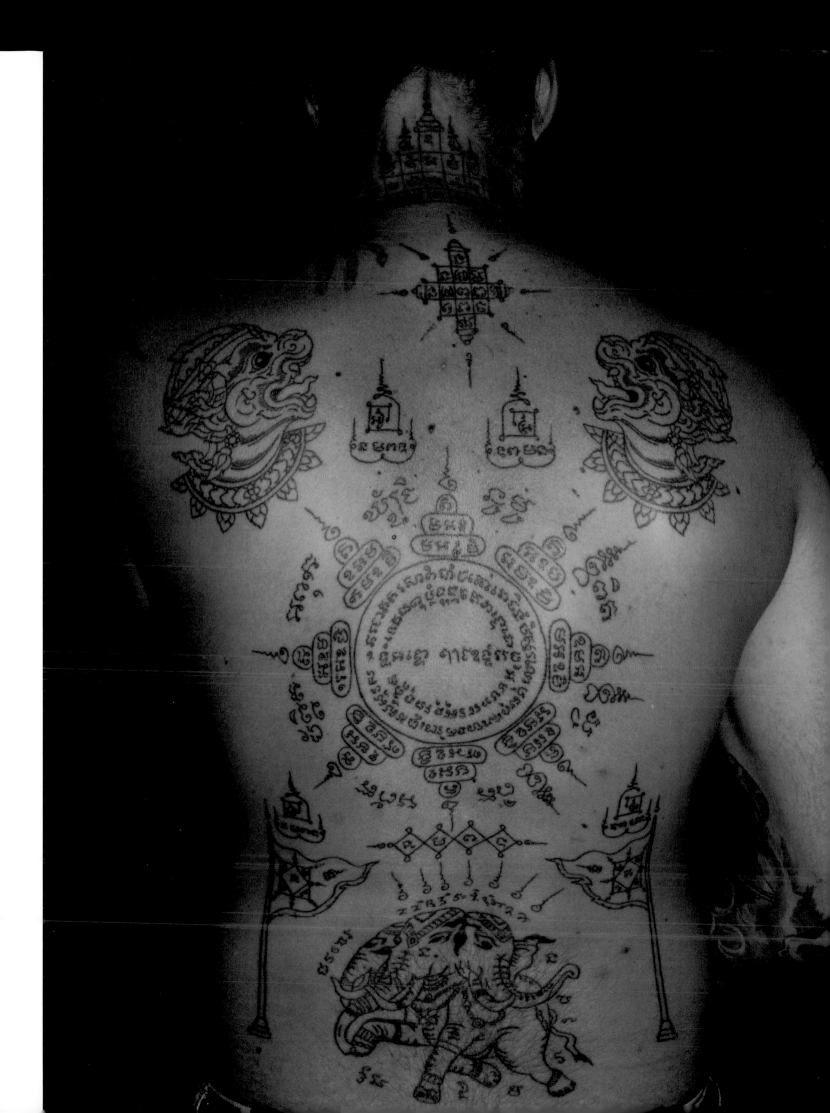

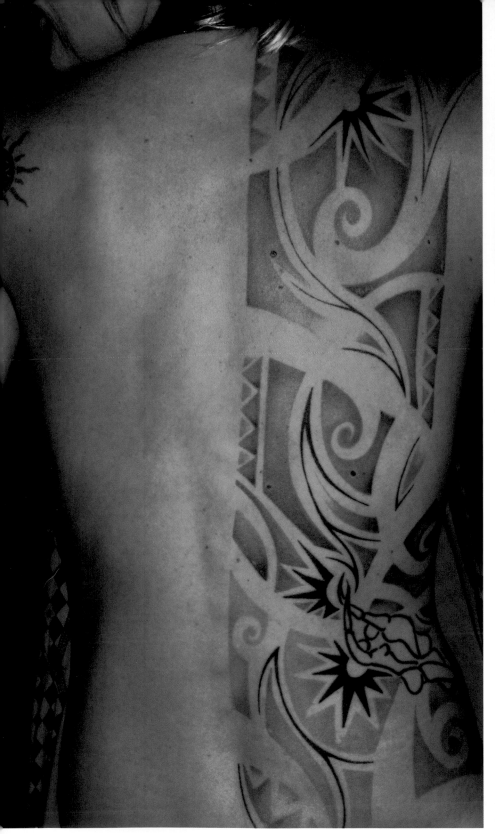

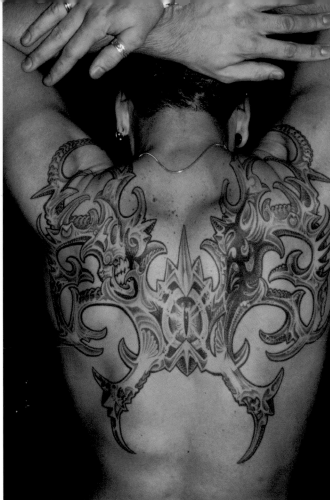

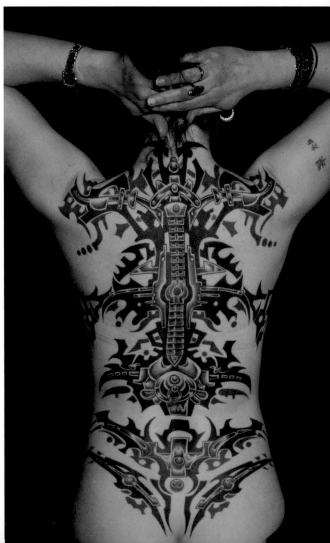

Above: A delicate black and grey tattoo (*by Anna Baumann, Klagenfurt, Austria*).

Top right: Intricate tribal art incorporating subtle grey nuances. *Tattoo by Wiesauer, Austria*

Right: Bold tribal work in which black is mixed with colour. *Tattoo by Jori, Manchester, UK*

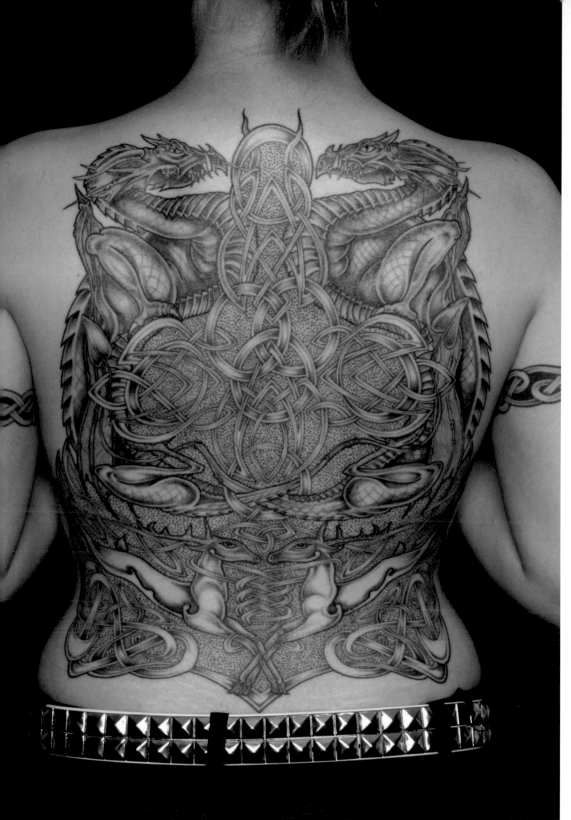

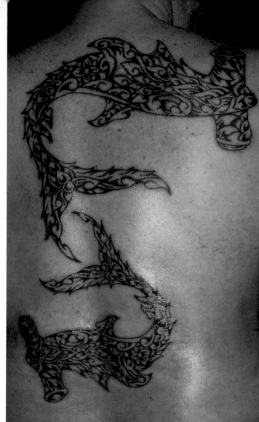

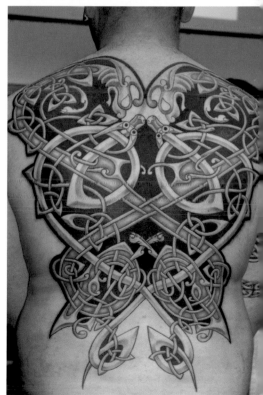

Above and bottom right: These elaborate Celtic designs incorporate several traditional motifs and animal features. *Tattoos by (above) Shaun Clifford, Images on Skin, and (right) Spacey, Bizarre Ink*

Top right: Hammerhead sharks depicted with abstract tribal lines. *Tattoo by Keng Modern*

Old-school sensibilities

Old-school tattoos are usually considered to be Americana-style illustrations with a bold, black outline and a variety of simple designs based on nautical, Native American, navy and biker symbols. Traditional motifs such as panthers, hearts, swallows, anchors, skulls, pin-ups, roses, mermaids, cherries, sharks, daggers and eagles are widely recognized as being part of the genre, which flourished between the 1930s and 1960s. The tattoos were usually embellished with primary colours and little or no shading, as the choice of coloured inks was limited at the time and tattoo machines did not allow for subtle tonal nuances.

Now more popular than ever, with vintage themes reworked in a 'new-traditional' style, old-school tattoo designs have crossed over into the mainstream, with legendary artists like Sailor Jerry Collins and Ed Hardy's artwork being licensed for a variety of merchandise from clothing to tattoo equipment to spirit bottles. The success of the alternative burlesque scene has also contributed to the enduring appeal of old-school tattoos, with performers and models reinventing themselves based on the stars of yesteryear, while at the same time updating the look with tattoos that are often in the new-traditional style. As a result, the visibility of traditional tattoo artwork has boomed, aided by the emergence of the 'rockabilly' scene and by a renewed interest in vintage and vintage-inspired clothing.

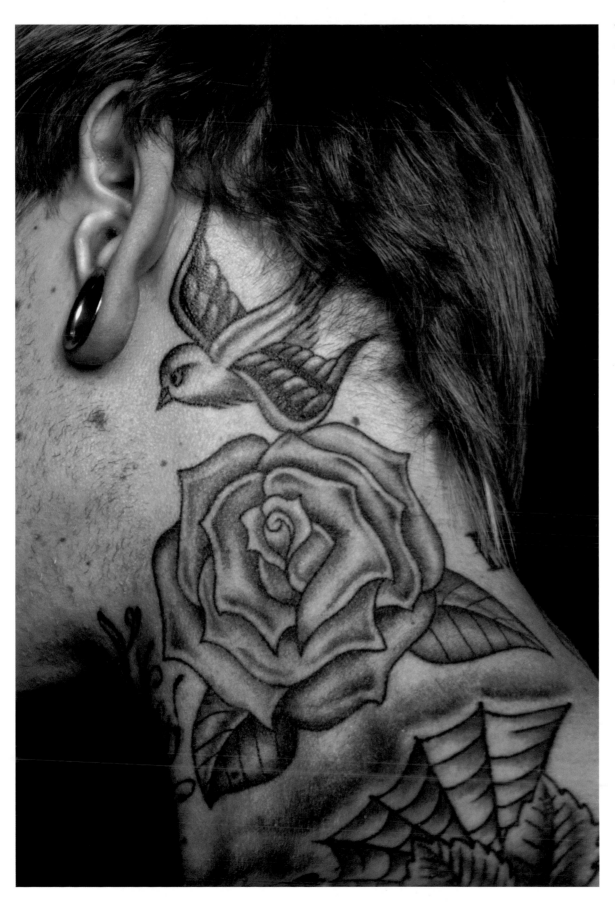

Two traditional old-school motifs, the swallow and the rose, reproduced in black and grey. *Tattoo by John Robbetts, Hardcore Ink, Dorsetshire, UK*

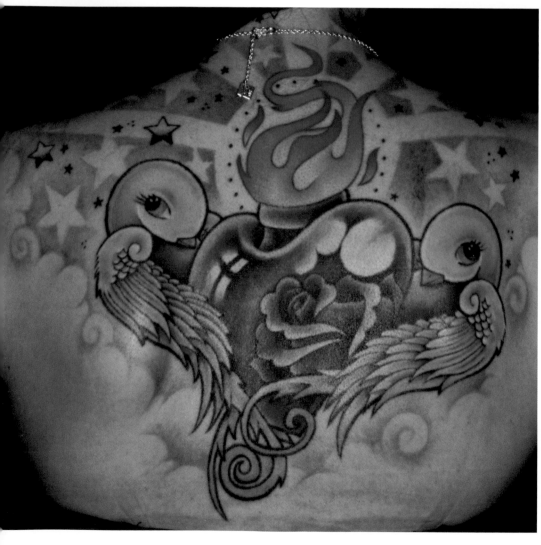

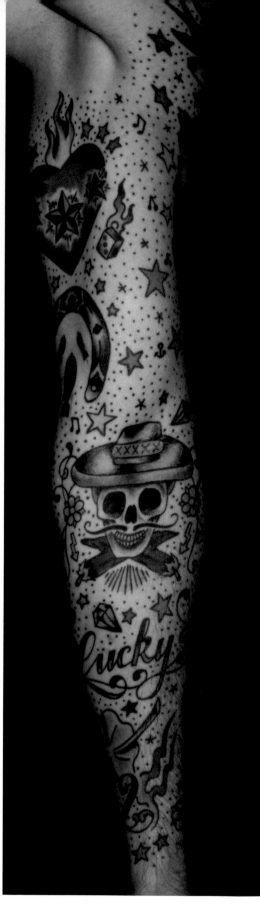

Top: Two old-school birds mirror each other. *Tattoo by Leah Moule, Spear Studio, Birmingham, UK*

Bottom: A modern interpretation of a love heart complete with love birds, stars, rose and flame. *Tattoo by Jo Harrison, Modern Body Art, Birmingham, UK*

Arm decorated with several old-school icons such as the skull, stars, flames, diamonds, a horseshoe, a die and a lucky clover. *Tattoo by Max Tattoos to the Max, Bad Ischl, Austria*

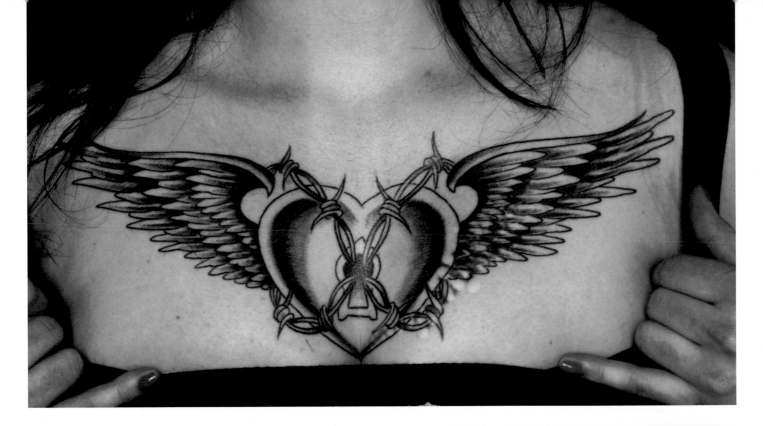

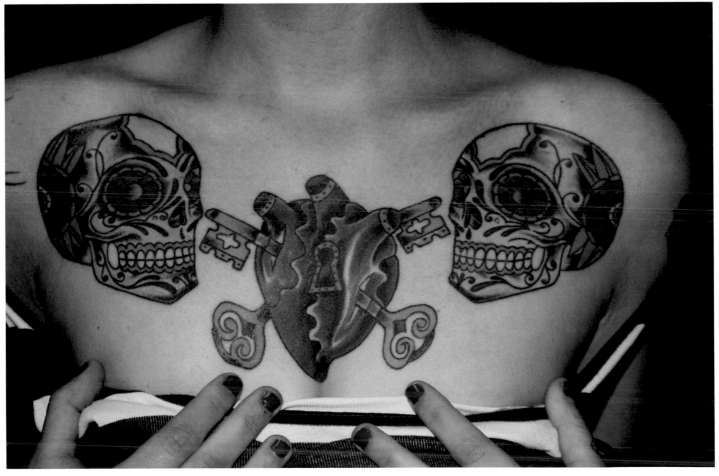

Top: A stark modern representation of a winged heart with barbed wire around it in black and grey. *Tattoo by Javi Lee, Jolie Rouge, London, UK*

Bottom: Traditional motifs such as the sugar skulls and a heart under lock and key, this time depicted in anatomical detail. *Tattoo by Enrico WWST, Oristano, Italy*

Skulls

Originally the domain of pirates' flags and invested with a strong gothic aesthetic, skulls seem to have partially transcended their connotation of death and can be found as decoration on people's skin in a variety of styles. Tattoos of demonic and chilling human skulls still abound – propagated primarily by the horror genre – and they are of course still a symbol used to warn of poisons and other deadly dangers, but there have been so many reinterpretations of this iconic symbol that it has come to acquire a variety of meanings, depending on its representation, style and context.

Skull tattoos are part of the 'old school' of tattooing which offered a basic interpretation of themes that reflected people's lives and interests (see page 52). The skull of that time was basic, without shading, and it was a symbol often used by biker gangs as a death-defying amulet. Indeed, the skull was a favourite among sailors for very similar reasons: it was a sign of courage, of being able to face the unknown without fears. When pirates first adopted it (with crossbones) its shock value was used to intimidate their adversaries.

Perhaps surprisingly, the skull sometimes seems to be a positive signifier of renewal rather than a symbol of death. If we look at the meaning of the skull (and the skeleton) in tarot cards, for example, it is a symbol of change and renewal, not of impending doom. However, it is often a reminder of the transience of life and of our own mortality (much like the cherry blossom in Japanese culture, see page 29). The skull can also represent overcoming a hardship or surviving an illness or an ordeal. Underlying its intimidating appearance is a subtext of strength and survival. A flaming skull is still closely associated with an outlaw status, because it is mostly seen on bikes, helmets or 'hot rod' cars and it is embraced by those who see themselves on the edges of society.

The skull has pride of place in many religious cultures: in the Christian tradition it represents redemption, appearing in religious paintings as a symbol of a life lived in virtue. The crucifix is sometimes represented with a skull at its base, possibly indicating the site of the crucifixion, Golgotha, which literally translates as 'place of the skull'. It is also taken to signify Jesus' triumph over death.

Hindu deity Kali wears a necklace of skulls, while Yama, the lord of death in Buddhism and Hinduism, wears five skulls around his head which represent the defeat of anger, greed, pride, ignorance and envy. In many Tibetan-inspired tattoos we often find depicted exquisite skulls decorated with gold and copper and semi-precious stones. These are traditionally

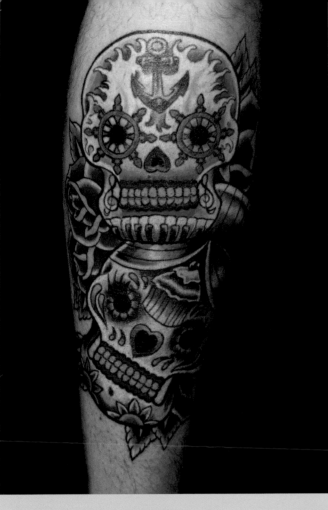

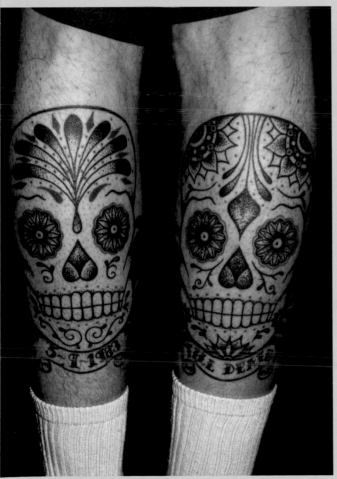

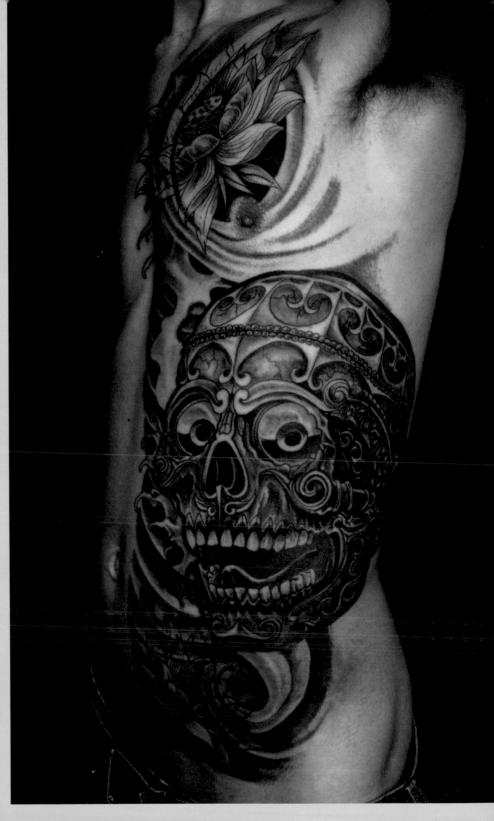

Above: Tibetan *kapala* ritualistic skull. These human skulls, often ornately decorated with jewels and carvings, were — and still are to this day — considered a legacy of ancient traditions of human sacrifice and are used as bowls and drinking vessels during rituals. *Tattoo by Derek Campbell*

Top left and left: Different interpretations of the Mexican Day of the Dead sugar skulls. On 1–2 November, it is traditional in southern and central Mexico to remember and honour deceased loved ones with music, food and drink and celebrations. *Tattoos by (above left) Jeff Ortega, Evil from the Needle and (left) Woody, Into You, Brighton, UK*

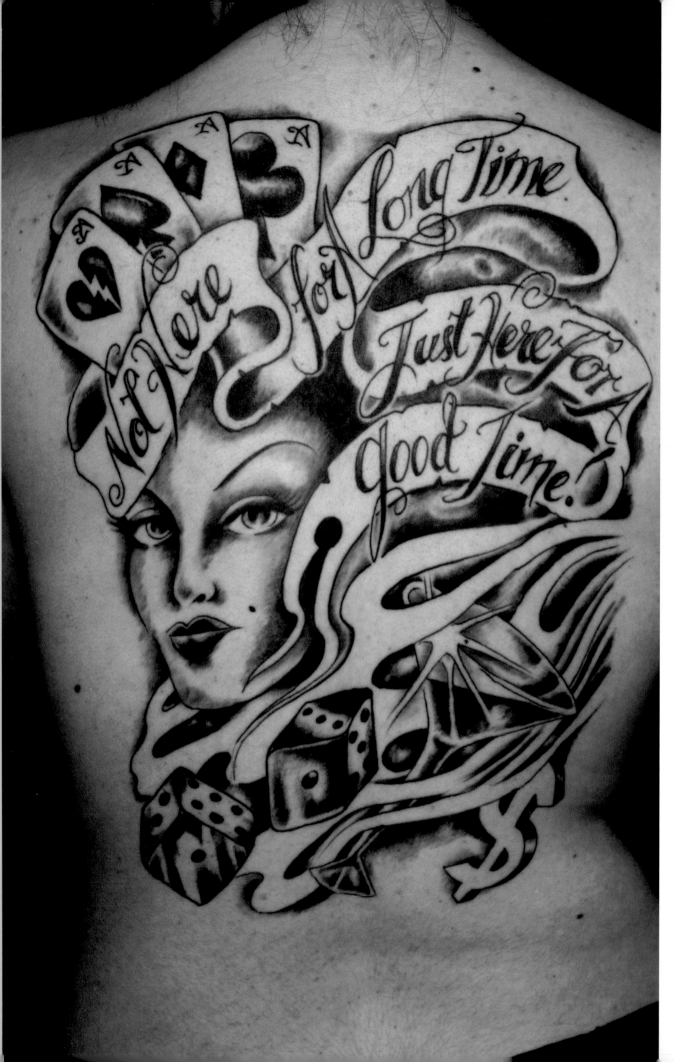

A monochrome rendition of old-school themes: aces from a pack of cards, a pin-up portrait, dice, a cocktail glass and a tag line in old script. *Tattoo by Martin, Inkhouse Tattoo, Leicester, UK*

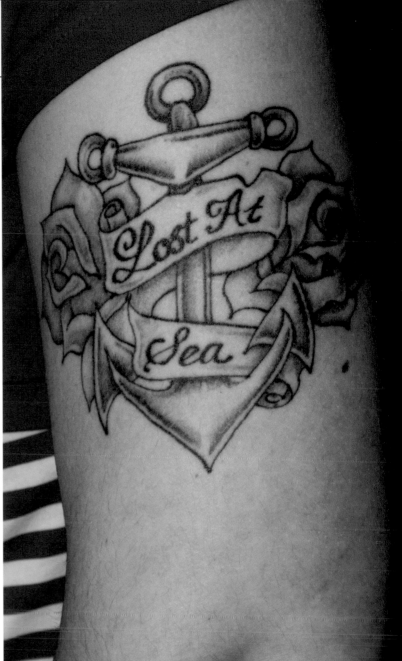

Above: A lively skeleton liberally inspired by the Day of the Dead Mexican tradition. *Tattoo by Dawnii, Painted Lady Tattoo Parlour*

Top right: A nautical theme for this black and grey tattoo: an anchor and a message framed by roses. *Tattoo by Beth, Shoreline Tattoos, St Ives, UK*

Right: *Tattoo by Stuart Salmon*

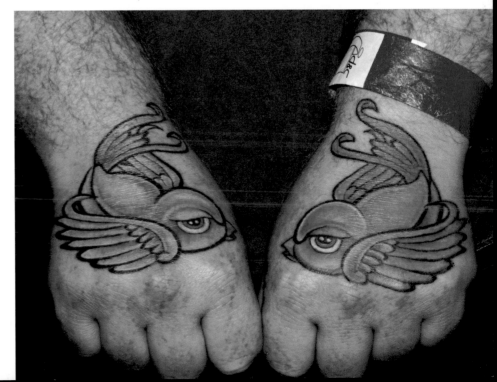

The pin-up

One way or another, men have always worshipped images of women. Whether extolled as a symbol of fertility, immortalized as an idol of sublime beauty or venerated in saint-like maternity, the female form has been admired and adored for almost as long as it has existed.

The emancipation of women in the first half of the 20th century was set to alter forever the depiction of women in art. The suffragettes and flappers began the process — in a new age of enlightenment and liberalism, no longer did prudish Victorian sensibilities reign eternal for the modern woman. It was during the wartime years of the 1940s that photographs of alluring models and actresses — Betty Grable and Rita Hayworth at the forefront — first took hold among soldiers and GIs posted far from home, who would tack them in their lockers, and even paint representations on their aeroplanes.

The pin-up girl was born.

What was special about pin-up art was that the model was usually imbued with girl-next-door charm: she was pretty and sexy, but not unattainable, and she was never a temptress or a *femme fatale*. The pin-up represented a slice of innocent Americana; a flirtatious girl who was beautiful but unthreatening, suggesting nudity rather than showing it.

After the war, pin-up art exploded into the mainstream: magazine covers, pulp books and advertising featured images by some of the most influential pin-up artists of the time such as — among others — Gil Elvgren, Antonio Vargas, Earl Moran, Al Buell, Art Frahm, George Petty, Billy DeVorss and Ed Runci. Although successful in their own right, these artists were shunned by the elitist art world. It is a snobbery that still exists today: one only needs to look at the chasm between low- and high-brow art to find it.

The so-called 'cheesecake' pin-up genre had its heyday in the 1950s, when a girl called Bettie Page started modelling. Her tremendous influence still resonates today. Endless portraits, tattoos and illustrations have been inspired by this pin-up queen over the years and sixty years on, pin-up models continue to emulate her. Her unique look is now more popular than ever, with the ubiquitous burlesque revival and tongue-in-cheek retro pictures of genre stars like Immodesty Blaize and Dita Von Teese.

Tattoo by Nutz,
Ware, UK

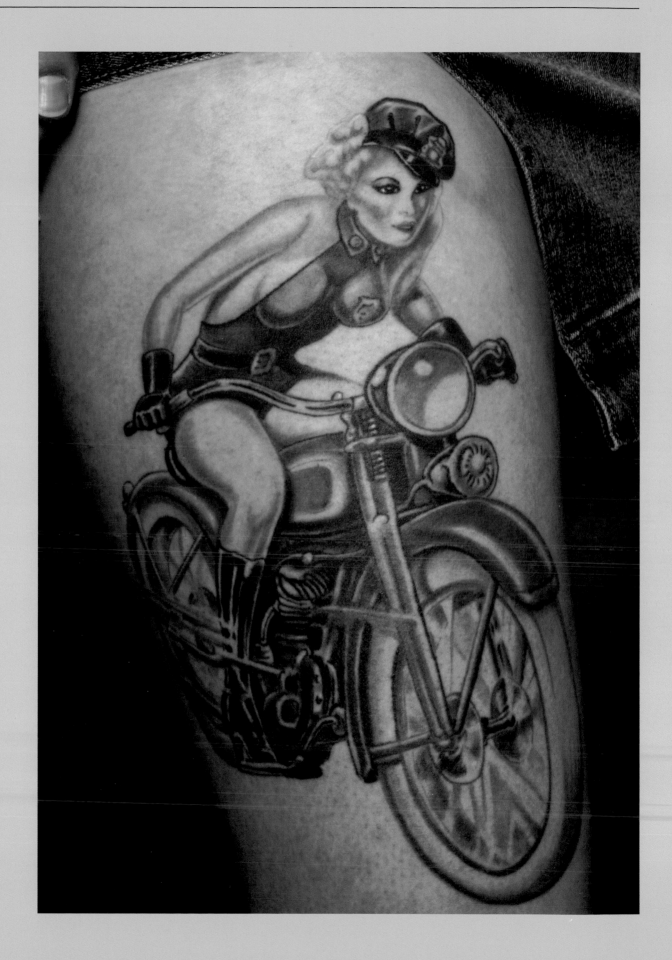

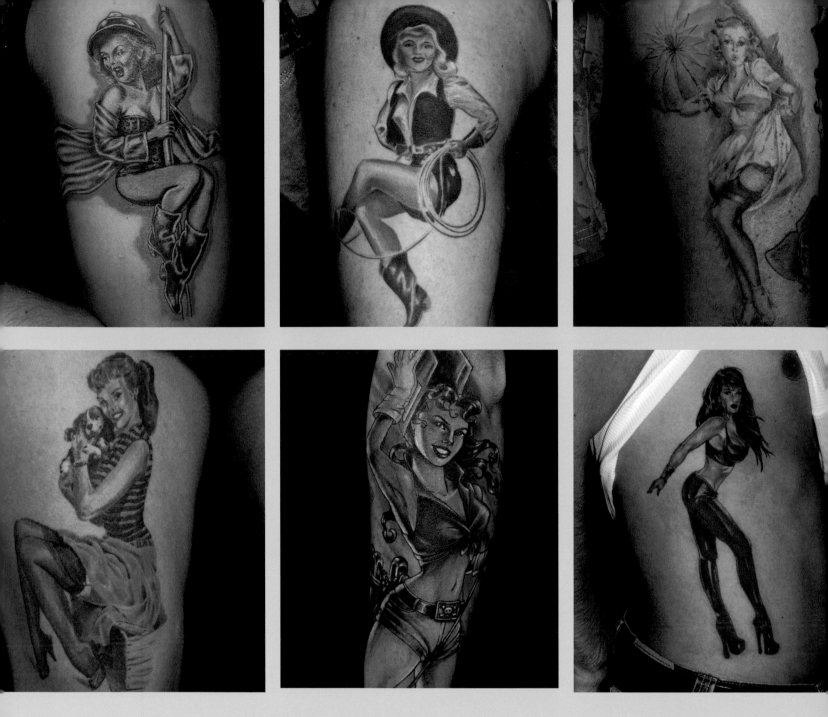

The tradition of pin-up art continues today thanks to the contribution of artists like Olivia De Berardinis, Sorayama, Joe Capobianco and Vince Ray. Their work is edgy and beautiful, often referencing the visual lexicon introduced by the pin-up masters. Olivia's subjects, which include everything from vintage pin-up icons to contemporary glamour models, feature her own inimitable style; for instance, she adds tattoos to one of her girls, giving birth to new iconic skin imagery. It is a tribute to her talent that some of the most enduring images of Bettie Page are in fact Olivia's interpretation of Page's heyday image.

Hajime Sorayama has subverted the genre with his über-sexy robotic pin-ups, polished, airbrushed and distinctly futuristic. Joe Capobianco's sassy girls (see pages 56—7) owe much to comic book art and Japanese manga, while Vince Ray's work often depicts powerful girls clad in fetish attire, clearly an object of desire, but never objectified.

Pin-up art has never gone away: it has merely adapted and evolved. Today, it remains the staple of many contemporary artists, as growing numbers choose to wear its feisty femininity, etched forever on their skin.

Opposite (clockwise from top left): *Tattoos by Ian, Comedian Tattoo, Glasgow, UK; Electric Tattoo, Holland; Amanda Sissons; Supreme Art; Hannah Aitchinson; Dorian Moreno, Black Indian Tattoo, Madrid, Spain*

Right: *Tattoo by Dawnii*

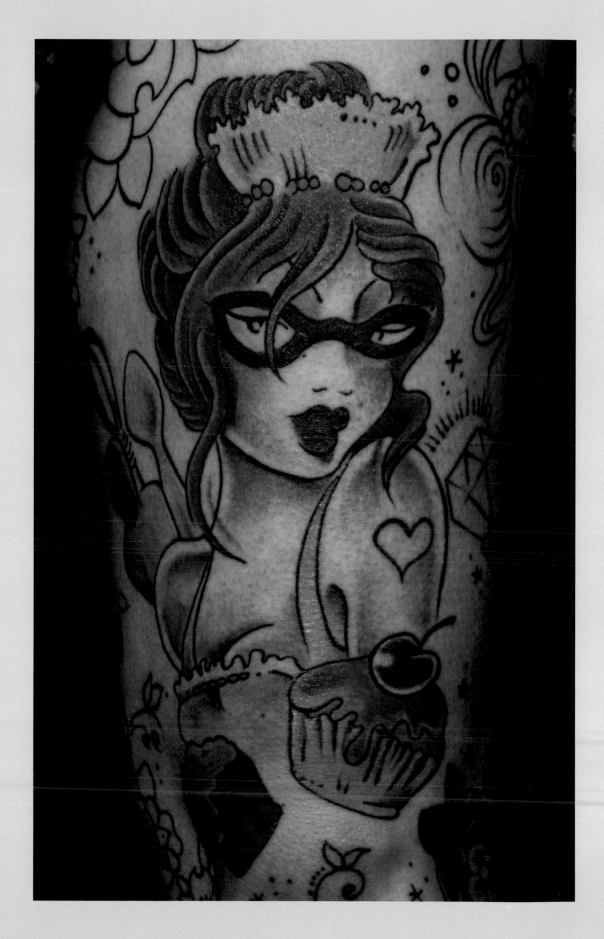

In Fantasy Land

Cartoons, legends and comic books all have their roots in the realm of childhood. They exist to nurture young imaginations, to teach us to read and to help us learn about the world around us in a safe environment. Some of us simply never grow out of such escapism. Others continue to foster, long into adulthood, fond memories of these magical fantasy worlds: the first stories that made us daydream. Whatever the motivation, there are many tattoo lovers who decorate their bodies with such fictional characters, some for their symbology, some for their nostalgia, and others simply for their frivolity.

Fairytales are more deeply rooted in our childhood subconscious than any other fantasy genre, and often our response to them is deeply visceral. Shaped by numerous retellings over the centuries, these tales have been adapted and reshaped, but their original subversive power is still there, resonant with some of us more than in others, their archetypal symbolism a cautionary tale or an amulet we carry forever on our skin.

Equally powerful are characters from myths and legends: gods and monsters who occupied our fervid imagination as youngsters come back to accompany us on our adult journey and invest us with their attributes. Winged horses, magical birds, voluptuous goddesses, dragons, creatures from medieval legends or characters from fantastical novels: they all reside in our subconscious and hold allegorical meanings.

Cartoon and manga characters, both common in tattoo work, celebrate the popular culture of our youth. While their characters are often highly iconic and occupy a cult-status, they also tend to be less enduring motifs than the characters in fairy tales and myth: popular culture by its very nature moves with the times and updates itself. As such, cartoon and manga tattoos are more likely to be prompted by a sense of sentimentality for bygone days. Equally, they might simply be chosen for their sense of fun and playfulness – and why not?

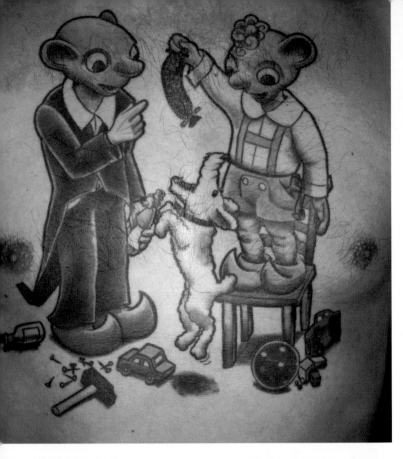

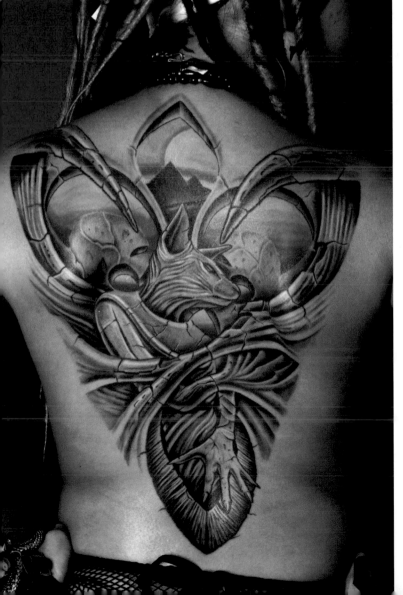

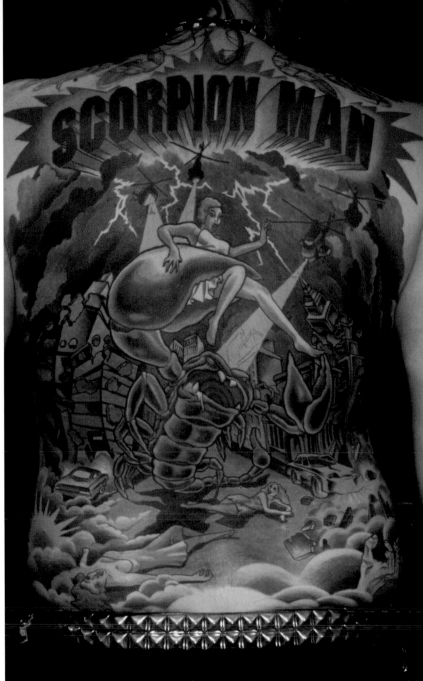

Above: A homage to comic book art in this back piece. *Tattoo by Tanina, Münster, Germany*

Top left: A piece taken from original artwork by Josef Lada. *Tattoo by Mathes Krivy, Zur Sonne Tattoo, Bamberg, Germany*

Left: A fantasy scenario in an unusual triangular shape. Stylized figures intertwine with the architectural elements depicted. *Tattoo by Astra, Moscow, Russia*

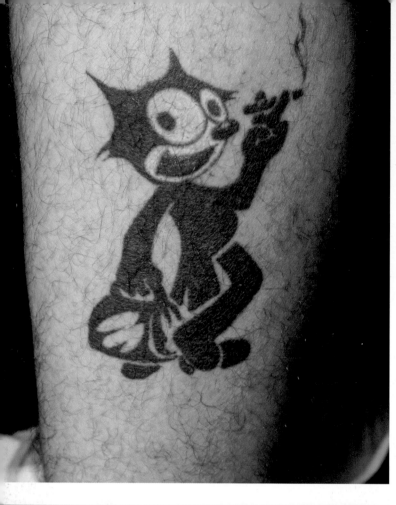

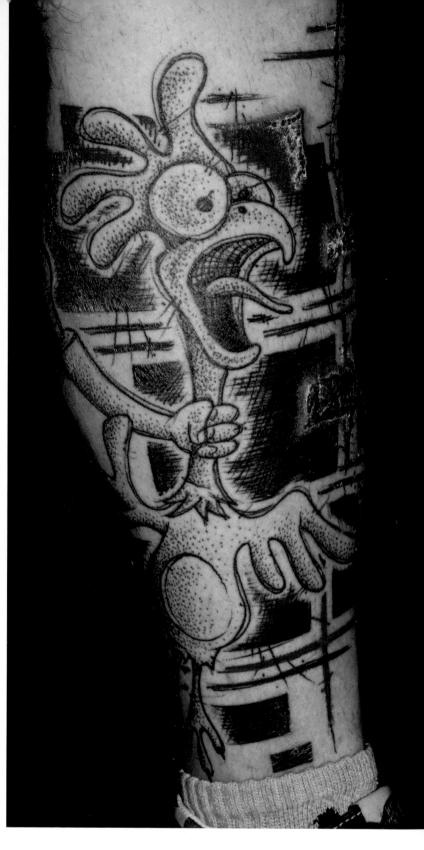

Above: A cartoonish rooster cries out in this original interpretation in a comic book style mixed with graphics elements. *Tattoo by Marc Riedmann, Germany*

Top left: Felix the cat is the subject of this quirky tribute number. *Tattoo by Kirdyk, Studio Artefact, St Petersburg, Russia*

Left: Stylized and somewhat haunting, this is a tattoo that mimics drawing techniques. *Tattoo by Moro Tattoo, Genoa, Italy*

Czech artist Josef Lada's unique style is the inspiration for this colourful back piece. *Tattoo by Mathes Krivy, Zur Sonne Tattoo, Bamberg, Germany*

Myth and Legend

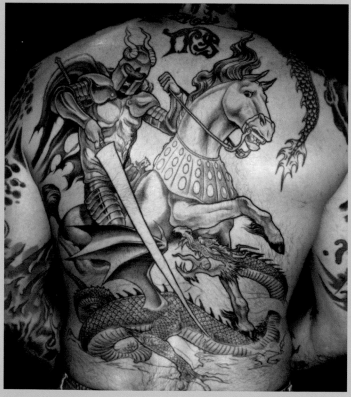

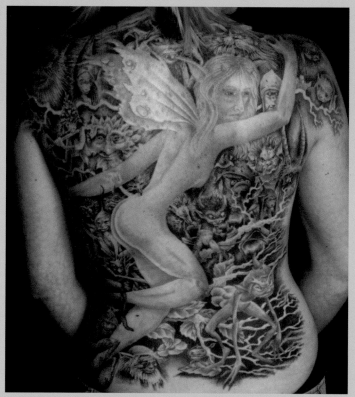

Tattoos by (left) Patrick Conlon, East Side Ink, New York, USA, and (right) Neil Bass, Tattoo FX

Since time immemorial people have been attracted to fantastical stories and myths. Our capacity to tell stories, and our need to make sense of the world around us, has pushed us to become storytellers from the very early stages of our existence, when we used rudimentary tools to carve our tales on cave walls. Stories pre-dating organized religions have been passed down, generation to generation, through the ages. They appeal to our subconscious, they provide archetypes for our psyche and give us a sense of history and belonging.

This powerful and laden symbology makes myth and legend a perfect theme to be represented in tattoos. Inspiration for such artwork is drawn from Grecian, Roman, Teutonic and Scandinavian mythological traditions, to name but a few. Here, we examine some of the most popular mythological tattoo motifs and what they represent.

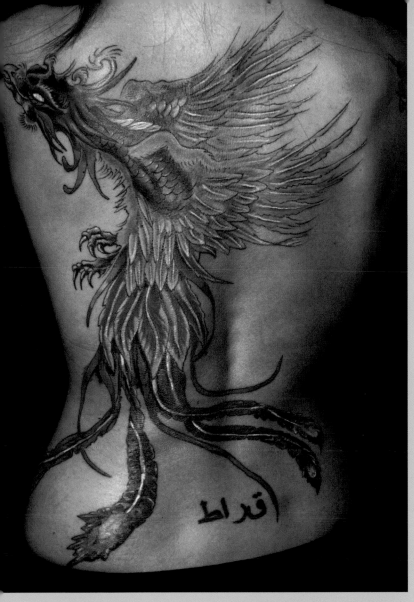

The **phoenix**, a mythological bird that could set itself on fire near the end of its life cycle and be reborn from its own ashes, is considered a symbol of rebirth and regeneration. Because of its resurrection, the phoenix is often used as a symbol of Christ, while in Chinese mythology it also represents the harmonious union of Yin and Yang.

The **dragon** has a very different role in European mythology to that of the Japanese and Eastern tradition (see page 28). In the West, it is not considered to be a benign creature (except in Welsh mythology). It is a magical being with a serpentine body, wings and four legs. It breathes fire and often guards treasures or something equally valuable. In more recent times, dragons have been portrayed as talking creatures and purveyors of wisdom.

The Gorgon **Medusa** exemplifies female rage and female sexuality, her beheading by a man signifying the triumph of a patriarchal society over female (sexual) power. She is also considered a symbol of ambiguity.

Aptly enough, **Pegasus**, the winged white horse, is sometimes said to be born from Medusa's severed head. Being the only one able to bring thunder to Zeus, Pegasus flies high, hence his adoption as a symbol of the immortality of the soul.

The **unicorn**, another magical white horse, is considered a rare animal of divine strength and ferocity, which represents purity.

Fairies, heavily represented in the Celtic tradition, as well as in other folklore tales from around the world, are supernatural beings that can be benevolent or malevolent towards humans. Trapped between heaven and earth, fairies are traditionally represented as tiny winged beings.

Elves, originally creatures of the Teutonic tradition, are delicately limbed beings who live in forests and traditionally have big eyes, pointed ears, high cheekbones, fair hair and fair skin. Their appearance varies depending on the different folklore tales they belong to, however, and they are often also portrayed as small creatures dressed in green with pointed ears and long noses (as in Santa's little helpers). Their prevalence in tattoos — as with many other mythical creatures — has seen a resurgence with the popularity of such movies as the *Lord of the Rings* trilogy and the *Harry Potter* franchise.

Witches also figure highly among the mythological figures used in tattooing. Ugly or beautiful, cartoonized or realistic, they represent feminine powers which can be used for good or evil. A much-maligned figure over the centuries, the stereotypical 'black witch' — warty, hook-nosed and equipped with a pointed black hat and broom — is in marked contrast with the Wiccan 'white witch' who represents a bond with the natural world.

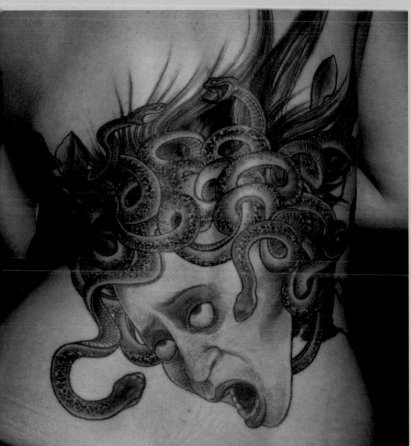

*Tattoos by (top left) Jan, Black Pearl, Bexhill, UK, and (left)
Phetrus, Angelic Hell, Brighton, UK*

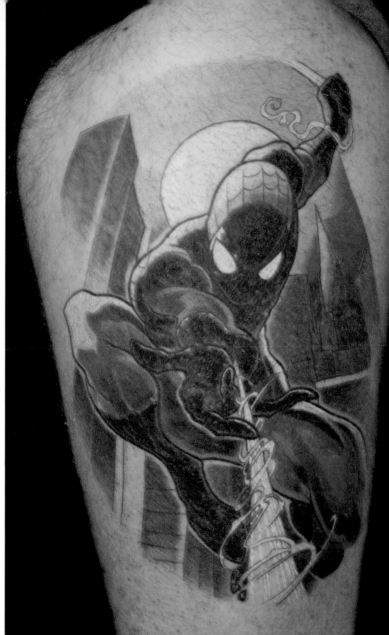
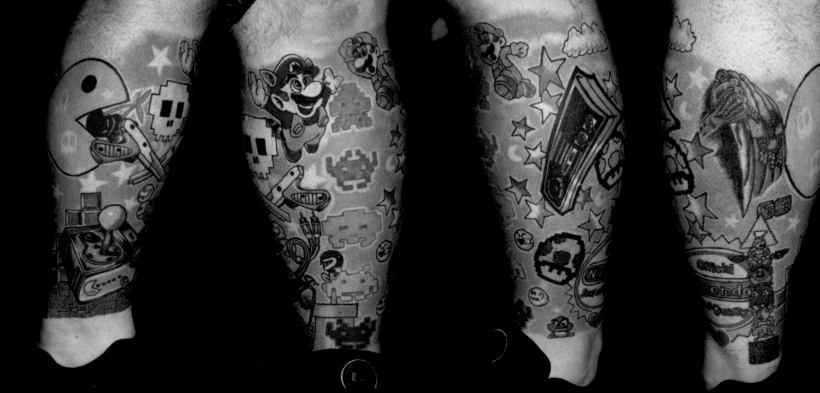

Opposite far left: A Cheshire cat crossed with an Aristocat results in this colourful piece. *Tattoo by Kult Tattoo, Krakow, Poland*

Opposite left: Spiderman seems to jump right off the skin. *Tattoo by Doc Denti, Arezzo, Italy*

Opposite bottom: A tribute to videogame icons old and new in this inventive and colourful piece. *Tattoo by Sean McCafferty*

Top right: A manga girl salutes you in her inimitable style from someone's neck. *Tattoo by Hannah Aitchinson*

Right: From the graphic novel *The Killing Joke*, here reproduced is one of the most striking images of the Joker. *Tattoo by Tom, Tattoo Studio Black Light Zone, Oederan, Germany*

Far right: A tattoo which looks like a sketch and depicts a strange creature. *Tattoo by Moro Tattoo, Genoa, Italy*

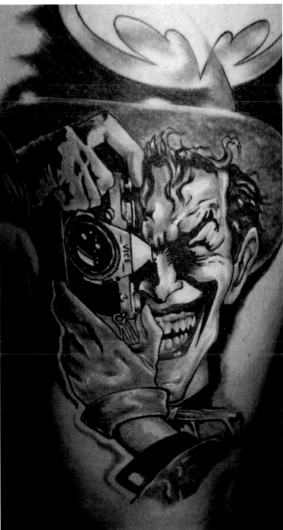

Idols and icons

Our enduring fascination with the talented and famous is well-documented. Fan worship in its modern form can make or break a career, and some of the most enduring icons of the 20th century have been entertainers, actors or singers whose images are etched into our subconscious thanks to the power of the visual media which created them: cinema, television, magazines and photography have all played their part in creating modern idolatry.

Marilyn Monroe, Elvis Presley, Audrey Hepburn, James Dean, Johnny Cash and countless others are commemorated in a frozen moment which epitomizes their being as we see them: beautiful, young, forever in their prime. And, of course, it's not only dead icons who make it on to our skin. Often we show our appreciation for a particular role, a movie or a fictitious character by choosing to have Don Corleone, Edward Scissorhands, Frankenstein or Darth Vader tattooed on our bodies, elevating our favourite movie to the realm of indelible mark.

Religious icons are another popular motif, their likeness often lifted from works of art in museums or sacred places. The visual we opt for is an artist's interpretation dictated by the dominant style of the time it was executed, our choice motivated by a sense of faith, a desire to immortalize our religious conviction or admiration for the original art.

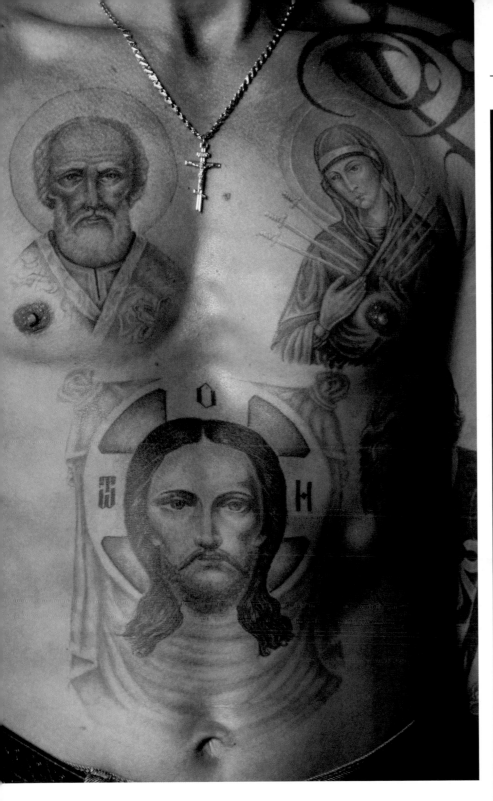

Above: Religious Christian icons decorate this man's torso in a striking monochrome (and a touch of colour). *Tattoo by Sergei*

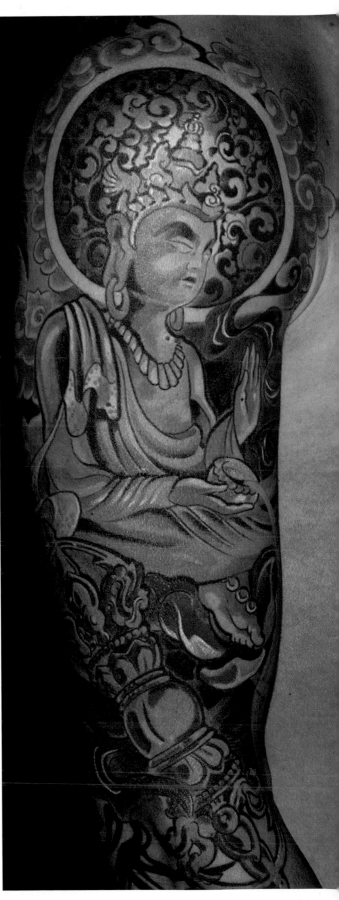

Right: A Buddha lit by the warm rays of the evening sun is the subject of this bright and colourful sleeve. *Tattoo by Leo, Naked Trust, Salzburg, Austria*

★ TRAILBLAZERS
Robert Hernandez

On first meeting Robert Hernandez one is struck by how quiet and unassuming he is: his unpretentious work ethic is a rare and refreshing attitude to encounter.

His tattoos are renowned for having a photo-realistic quality which, before Hernandez arrived, had never been seen in tattoo portraits. His use of the colour palette to render contrast creates almost a three-dimensional effect, and the portraits he produces are so vivid they seem to stand out from the skin. Born in Poland but resident in Spain since his teens, Hernandez already had an impressive art portfolio when he became an apprentice in a large Madrid studio. His unique technique was honed and perfected at a time when it was not yet fashionable or popular, while at the same time he learnt the basic techniques by tattooing all sorts of subjects and styles. The last decade has witnessed a considerable output of realistic and almost painterly tattoo work from Poland, and it is easy to see how influential Hernandez's Polish background has been in his photo-realistic work. Whether it's a portrait of a loved one, a horror-movie icon or a rock star tribute, Hernandez's tattoos promise never to be run-of-the-mill. His portraits usually transcend the original material, but his style tends to lean towards the 'dark' side.

He is most associated with small pieces — indeed, most portrait work tends to be small to medium size, although large Hernandez tattoos exist and are rather magnificent. His clients often start with a medium-size tattoo and add to it, building a relationship with the artist that continues for years. He does not begrudge those using his work as inspiration, so long as there is no out-and-out plagiarism involved — an ethical matter that comes down to the conscience of the individual artist (see page 16). He works from a small studio in Madrid and, perhaps surprisingly, is fairly easy to book, as he refuses to schedule his time too far in advance. Influenced heavily by his grandfather, a caricaturist, Hernandez creates tattoos that are both richly textured and reminiscent of the paintings and pastel work he likes to indulge in creating whenever he can.

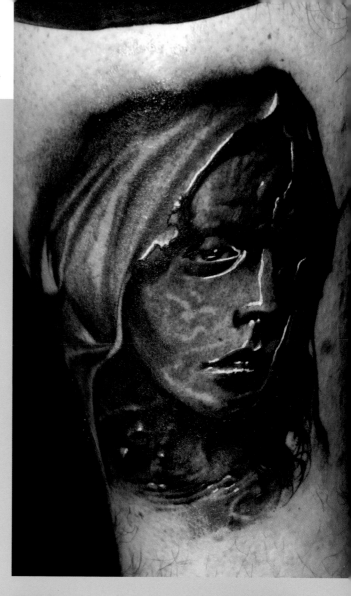

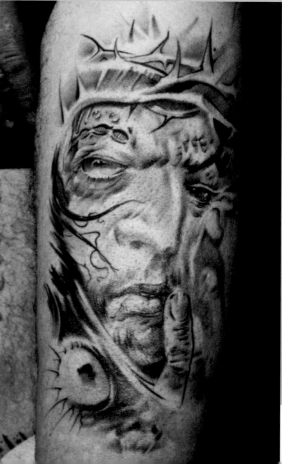

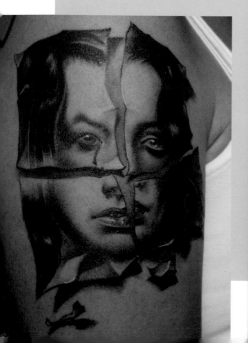

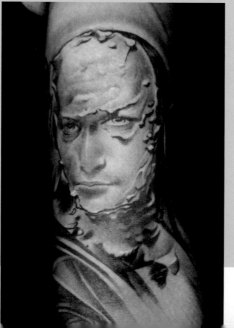

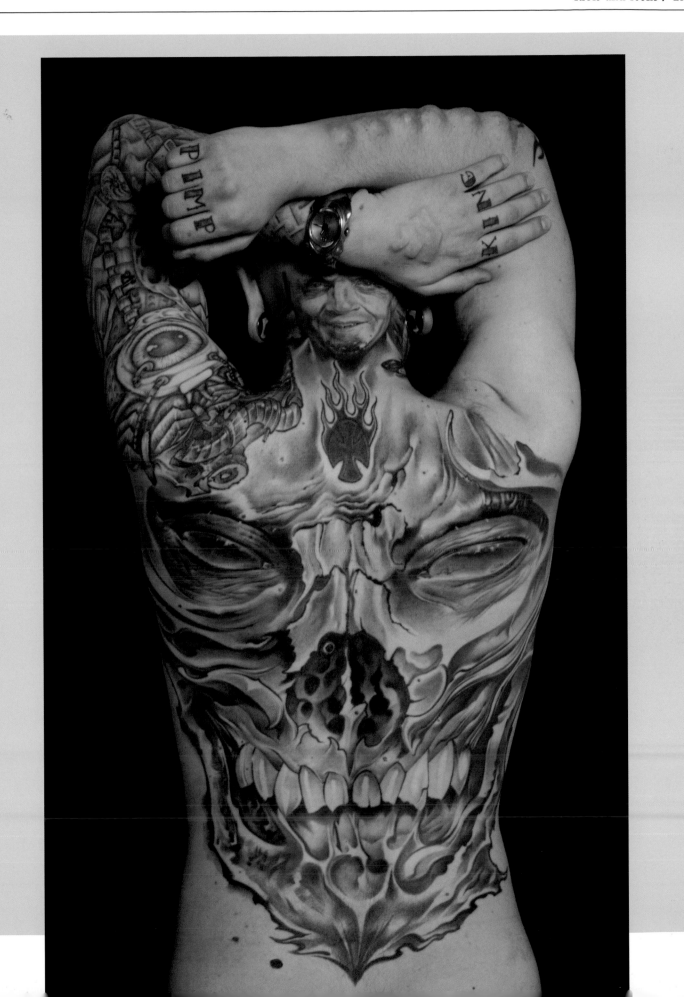

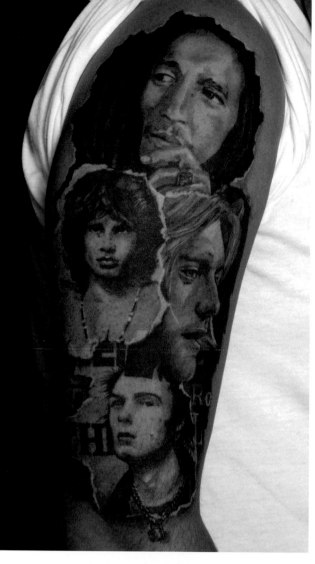

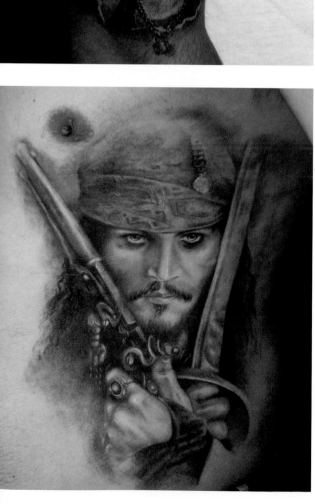

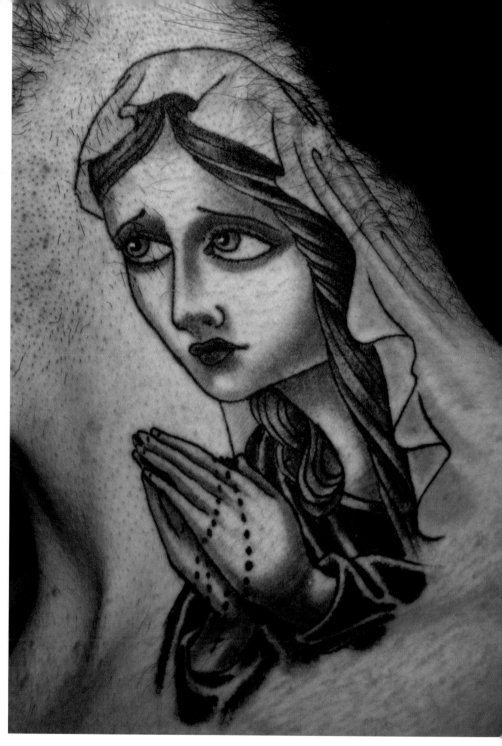

Above: A cartoon-inspired Virgin Mary adorns a man's neck. *Tattoo by Mo Coppoletta, The Family Business, London, UK*

Top left: A music lover's homage to dead rock icons: Bob Marley, Jim Morrison, Kurt Cobain and Sid Vicious feature in this music tribute. *Tattoo by Max Kol*

Left: One of the many tattoos depicting Johnny Depp in character, in this case as Captain Jack Sparrow from the *Pirates of the Caribbean* franchise. *Tattoo by Alexsandr Pashkov*

Opposite: *The Good, the Bad and the Ugly* features in glorious black and grey in this back piece. *Tattoo by Steve Priceman, Eternal Art, Upminster, UK*

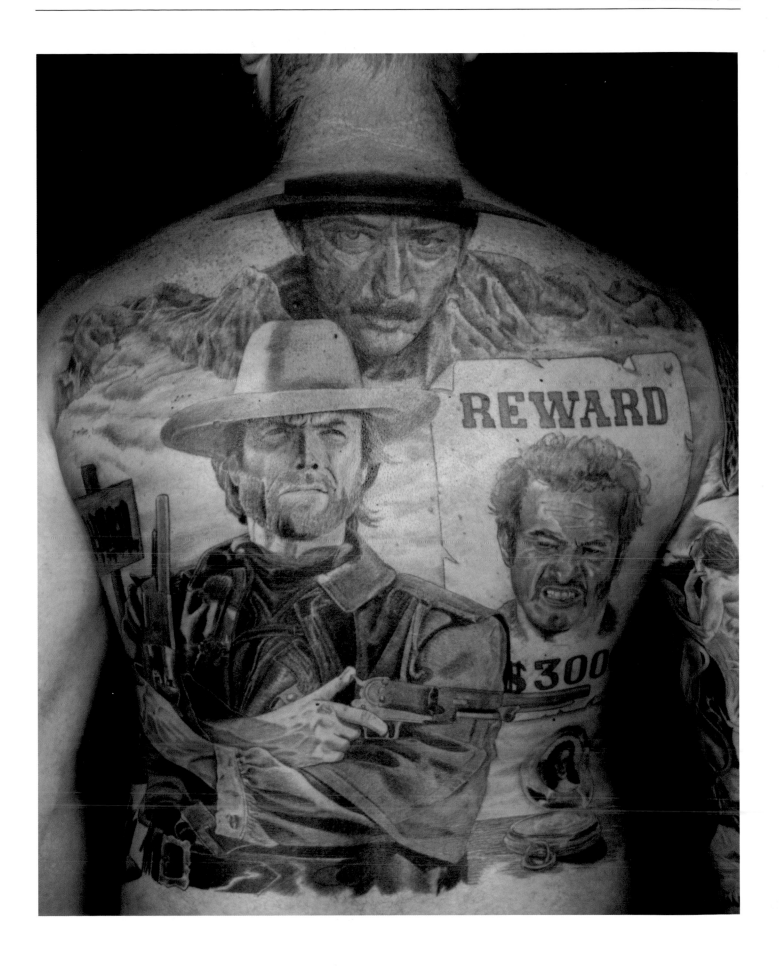

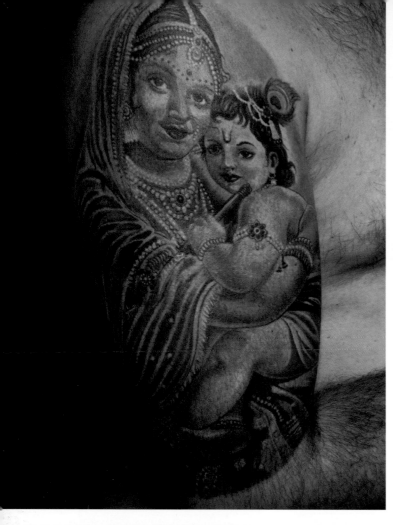

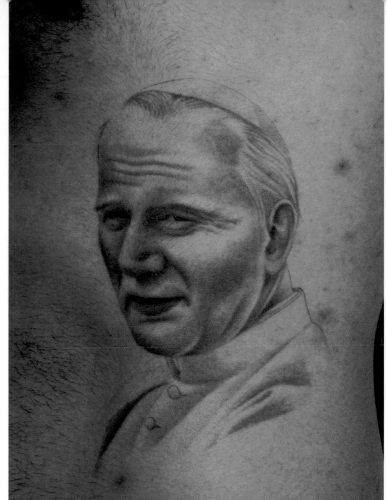

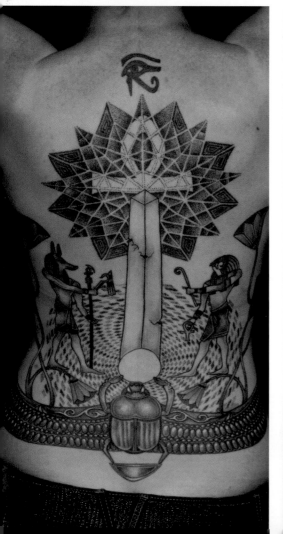

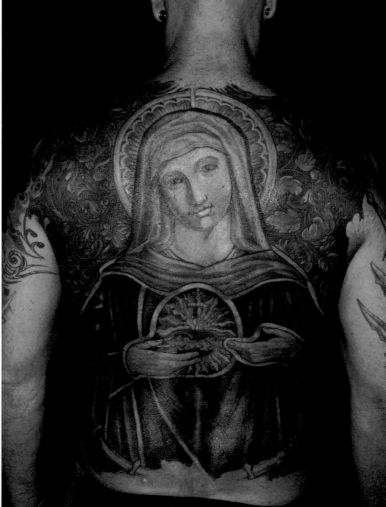

Top left: Eastern sensibilities emerge in this Hindu-inspired artwork. *Tattoo by Boris, Hungary*

Above: Pope John Paul II is rendered in delicate chiaroscuro. *Tattoo by Edoardo, Moko Tattoo, Rome, Italy*

Far left: A detailed black and grey back piece inspired by the religious symbols and hieroglyphics of ancient Egypt. *Tattoo by Alex, Dr Feelgood, UK*

Left: A large reproduction of the Virgin Mary covers a man's back. *Tattoo by Valentin Steinmann, Switzerland*

The Green Man

An enduring icon which has crossed cultures and millennia, the Green Man is present in many cultures around the world. This popular tattoo design appears as a face amidst a mass of foliage, giving it the appearance of a 'green' deity. Despite the fact that it pre-dates Christianity and bears an appearance which would normally mark it out as a pagan deity, the Green Man can often be found on church decorations as well as in Celtic art. Its clear relationship with nature and plant life marks it as a symbol of rebirth, indicating the life cycle that renews itself each spring.

The Green Man, or Foliate Head, is often (though not exclusively) represented alongside Celtic motifs, and it is believed to derive from the Celtic god of Nature. Its symbolic appearance as a woodland spirit then trickled down to several different cultures. It is likely that it was assimilated by established religions in an attempt to facilitate the integration of smaller populations with different beliefs.

Tattoo by Koma, Czech Republic

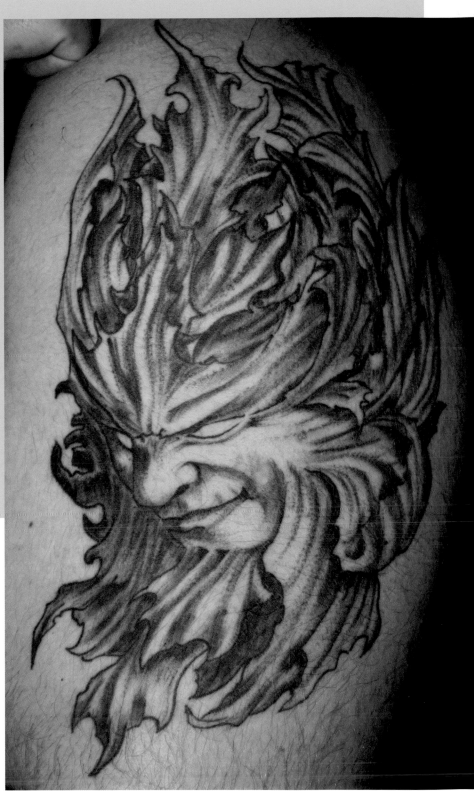

Tattoo by Stuart, Angelic Hell, Brighton, UK

Inspired by Nature

If the only limit for tattoo art is our imagination (or that of our tattoo artist), there is nothing to stop us from taking our inspiration from the beautiful natural world that surrounds us. And gone are the days of that seemingly ubiquitous minuscule butterfly motif: nature tattoos today are bigger and bolder than ever before.

Whether it is a fleeting vision of nature forever preserved in your living tattoo; an *in memoriam* tattoo for a lost beloved pet; or a totem animal to represent all those qualities we long for and admire – there are plenty of motivations behind tattoo work inspired by wildlife and the natural world.

Landscapes tend not to feature prominently in tattoo art except as backgrounds, but animals are firm favourites, marking us as animal lovers committed to a green ethos. Some animals are, of course, chosen for their symbolism: an eagle tattoo is associated with power and freedom, a panther is a symbol of strength and beauty, a dog represents loyalty, dolphins signify freedom; others are chosen from astrology charts and the Chinese Zodiac – and just sometimes, of course, our animal tattoo will simply be cute for cute's sake.

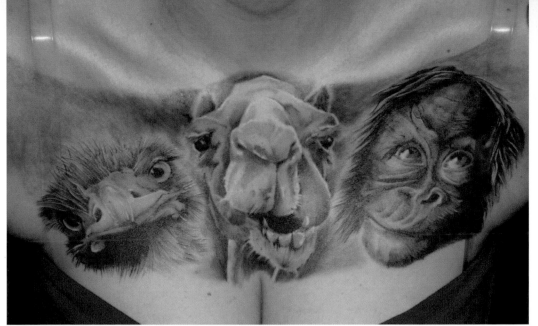

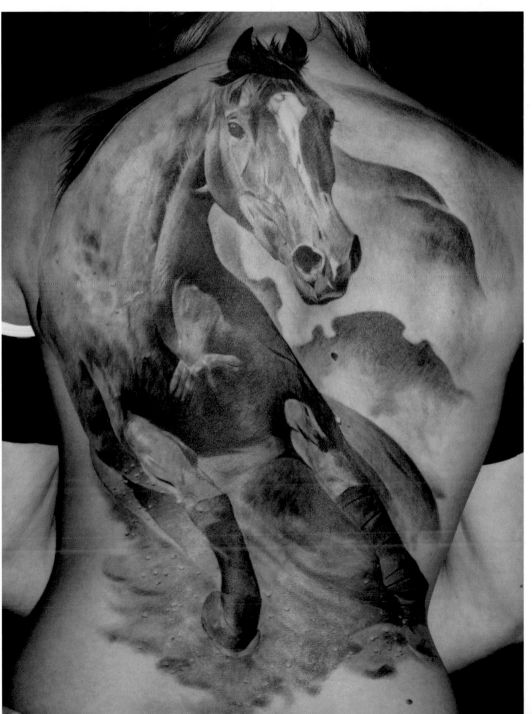

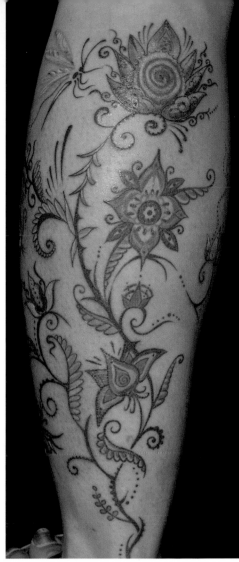

Above: A stylized floral theme. *Tattoo by Vampyria, Genoa, Italy*

Top left: Three animals' heads loom humorously from this lady's chest. *Tattoo by Fubio, Crazy Needles, Tivoli, Italy*

Left: A beautiful horse captured in great detail. *Tattoo by Igor Szablewski, Junior Ink, Warsaw, Poland*

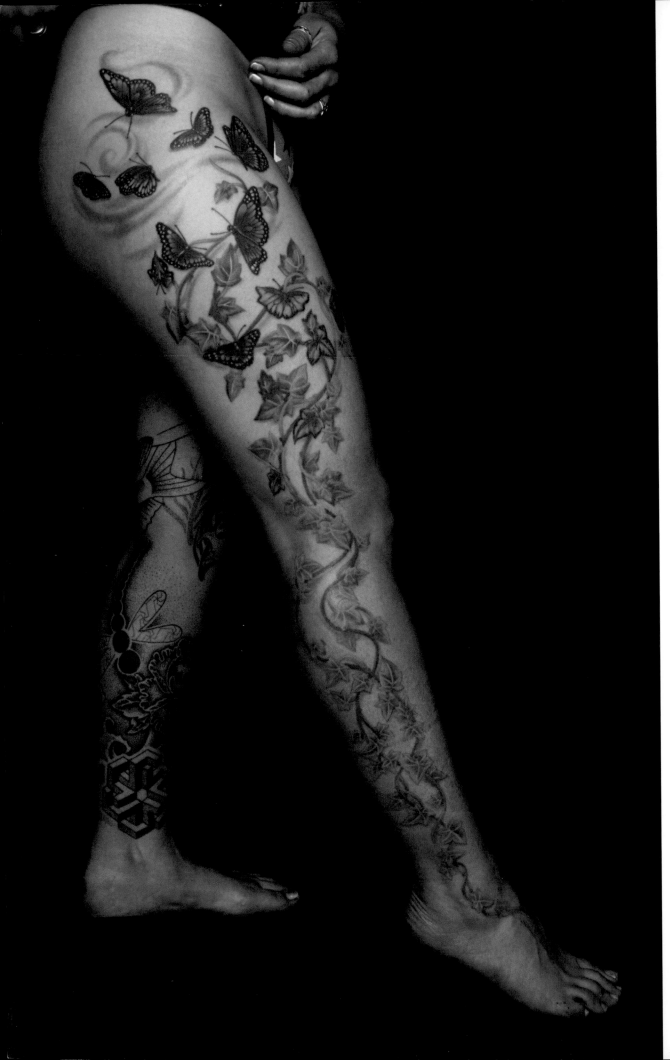

A naturalistic tattoo of butterflies and ivy in a large piece which manages to be light and airy by allowing non-tattooed skin to be the image backdrop. *Tattoo by Jo Harrison, Modern Body Art, Birmingham, UK*

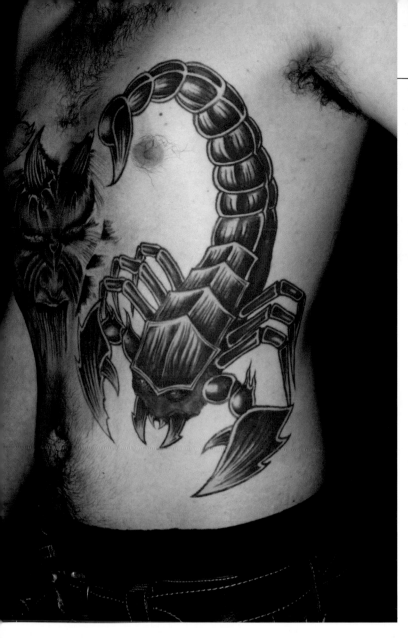

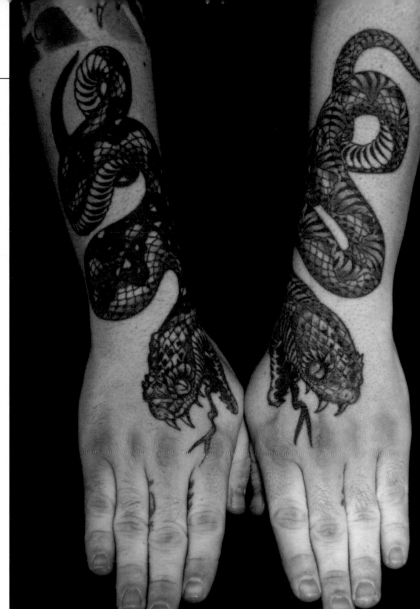

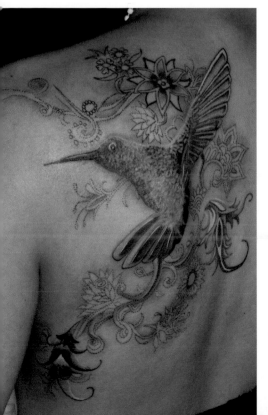

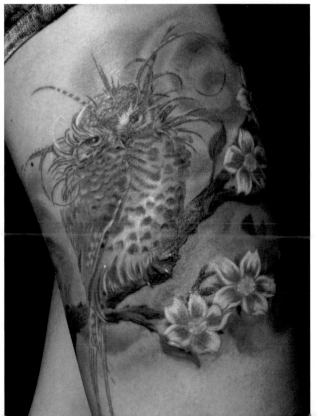

Above: Two snakes face each other in this bold design. *Tattoo by Lynn Akura, Magnum Opus, Brighton, UK*

Top left: An unusual depiction of a red scorpion without a black outline, possibly influenced by comic book art or video games. *Tattoo by Jason Hann*

Far left: A delicate design which blends colour and monochrome together subtly. *Tattoo by James Robinson, Inka, Brighton, UK*

Left: A beautifully nuanced bird rests on a blossoming tree branch. *Tattoo by Zmey, Moscow, Russia*

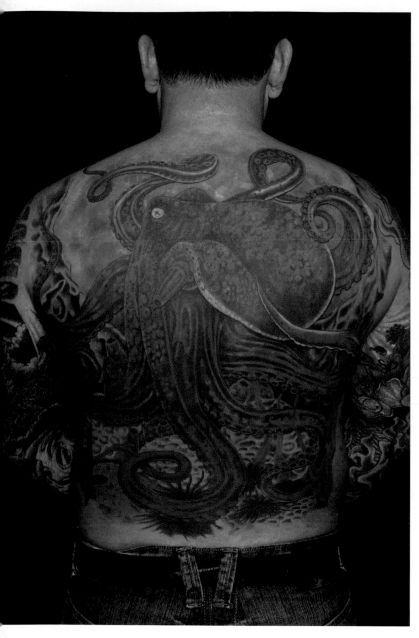

A giant octopus takes over a bright back piece in this sea-inspired tattoo (*by Ray Hunt, Medway, UK*)

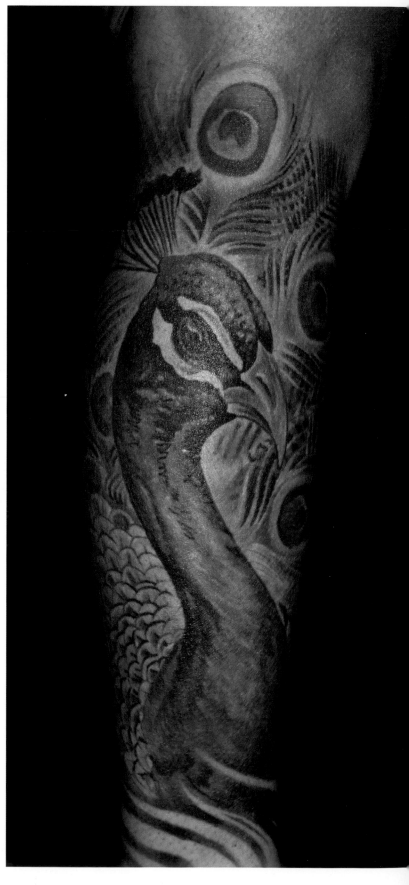

A striking peacock design adorns this leg. *Tattoo by Boris, Hungary*

A colourful back piece, made all the more naturalistic by the lack of a black outline to define the figures. *Tattoo by Igl, Stichtag*

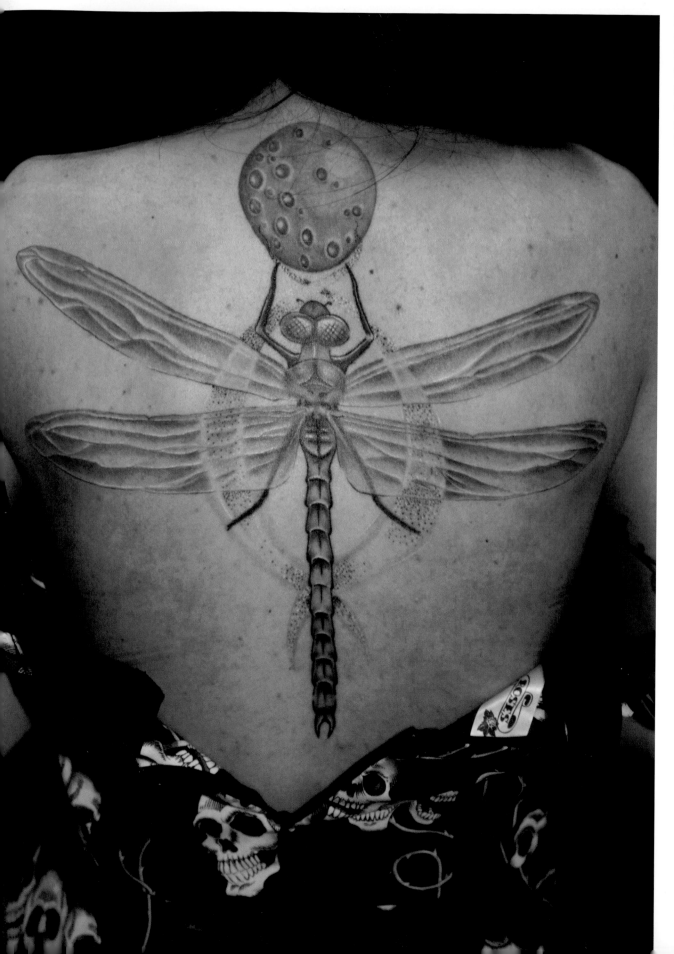

Magnified hundreds of times over, a dragonfly is a quirky idea for a back piece. In this case, the choice of black and grey allows the delicate detail on the wings to stand out. *Tattoo by Charro's Tattoo, Macerata, Italy*

Delicate and bright colours are this tattoo artist's trademark, here used to full advantage to render this tropical naturalistic piece. *Tattoo by Miss Nico, Berlin, Germany*

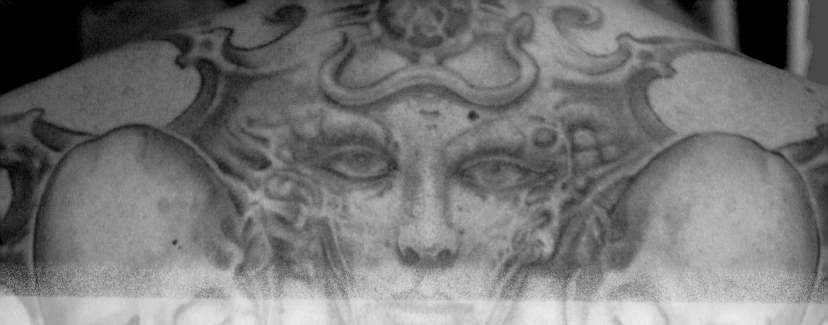

Biomechanics

Single-handedly originated by Swiss artist H.R. Giger (see page 96) in the 1980s, this cult genre would have probably stayed underground had it not been for the global success of the *Alien* franchise, for which Giger designed the creature of the title. Once *Alien* was in the collective consciousness, and with several best-selling books divulging Giger's work, admirers of his oeuvre began to render it permanently on their own skins.

There is something quite disquieting about the biomechanoid cyborgs born of Giger's imaginings. Some of the imagery is downright disturbing, yet strangely appealing, revealing an almost archetypal quality that perhaps speaks to our subconscious, telling of a past, not a future, which has spawned us.

Biomechanical work offers a futuristic vision of a fusion between man and machine, and, as such, its anatomical characteristics make it extremely adaptable for application to the human body. The tattoos are rendered on skin in a variety of forms – sometimes lifted entirely from Giger's books, and at other times freely reinterpreted by the tattoo artist and positioned in a way that enhances the wearer's body.

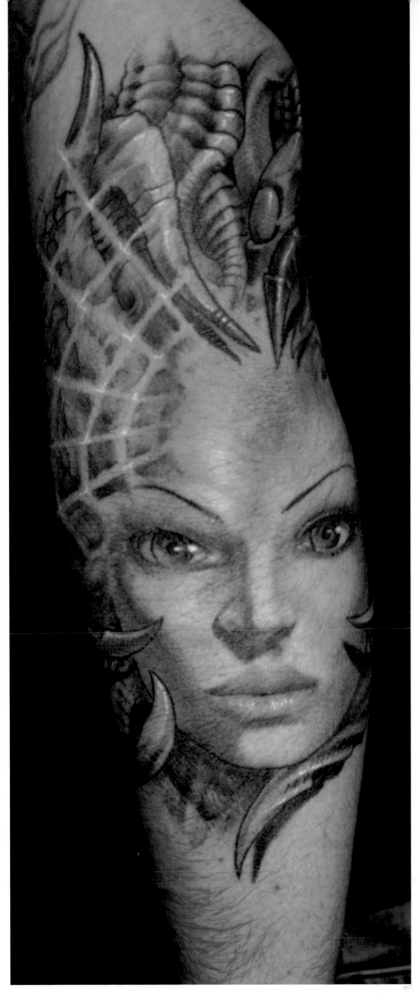

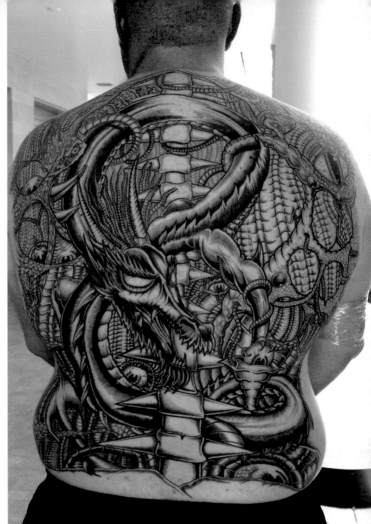

Above: A black and grey design which incorporates fantasy and Eastern elements (see the central dragon) within a biomechanic design. *Tattoo by Darryl B*

Left: A beautiful woman's portrait framed by unmistakable biomechanic claws. *Tattoo by Rico, Studio Z, Tønsberg, Norway*

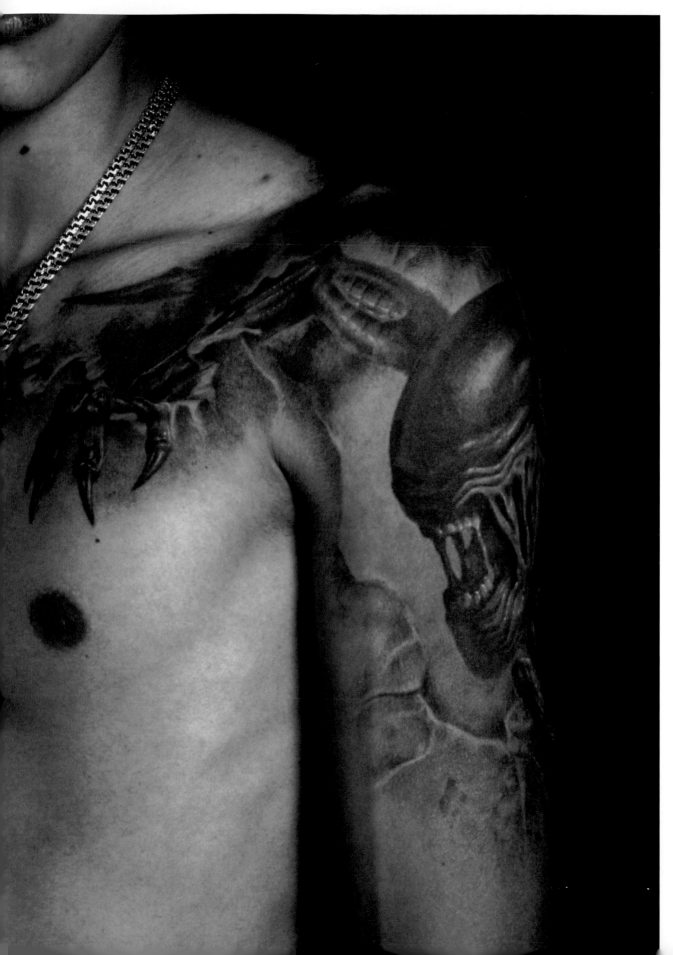

The creature from the *Alien* movies comes alive — yet again! — in this piece covering the shoulder and part of the chest. *Tattoo by Barsuk, Rostov-on-Don, Russia*

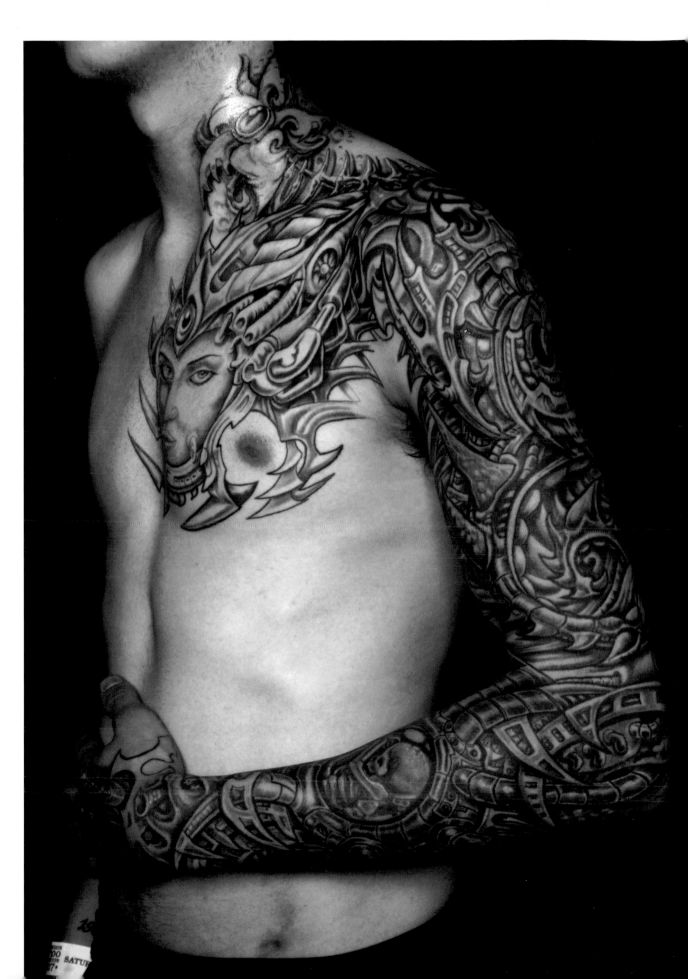

Tattoo by Nutz, Ware, UK

★ TRAILBLAZERS

H.R. Giger

By and large, tattoos are designed precisely for the medium in which they appear: that is, as artworks to be applied directly to the skin. But there are times when tattooing overlaps with other forms of art. One of the most striking examples of this is the groundbreaking work of one particular contemporary artist whose oeuvre, transposed as skin adornment, kick-started a whole new tattoo genre.

'Biomechanics', literally the application of mechanics to a biological system, takes its name from the eponymous 1988 book by the legendary Swiss artist H.R. Giger.

His transhuman interpretations of a powerfully sensual, nightmarish, futuristic fusion between man and machine have struck a chord with many who were looking for organic body decorations which moved beyond the traditional and the tribal, the two predominant genres in the tattoo world in the 1980s, when biomechanical work first started to make its mark on skin.

To call the man's work influential is almost an understatement. Whether you are familiar with his art or not, you will have come across some of Giger's work, as his unique vision has been percolated through mainstream movies (most famously in the *Alien* saga, *Species* and *Poltergeist II*), books, paintings, album covers, sculptures, computer games and posters, as well as living and breathing art on people's bodies.

Giger's inspired creation of the space creature in *Alien* earned him an Oscar in 1980 and drew in a whole new generation of fans who might not have otherwise been exposed to his art. Further movie work, as well as his involvement with various rock artists to create album artwork (Debbie Harry, Emerson Lake and Palmer, Carcass, Steve Stevens and more) have cemented his position as a cult artist, admired by millions, and yet not quite mainstream. Still, this alone does not explain the appeal of his work.

Giger's leap to a future that sees man and machine organically intertwined in an evolutionary biological dystopia is as powerful as it can be disturbing. His unique designs have inspired myriad tattoos, either in homage to the master of this fantasy imagery, or as part of their owners' reinvention of themselves as Gigeresque cyborgs — at least on the surface of their own skin. What Giger enthusiasts choose to have tattooed varies wildly: from pieces of artwork directly lifted from his books to original biomechanical designs liberally inspired by Giger and reinterpreted by tattoo artists. If he'd had royalties every time a piece of his was tattooed on somebody, he would doubtless be a multi-billionaire.

Technically, the inking of Giger's organic work allows the tattoo artist to follow the body's natural contours without having to conform to a strictly physiological

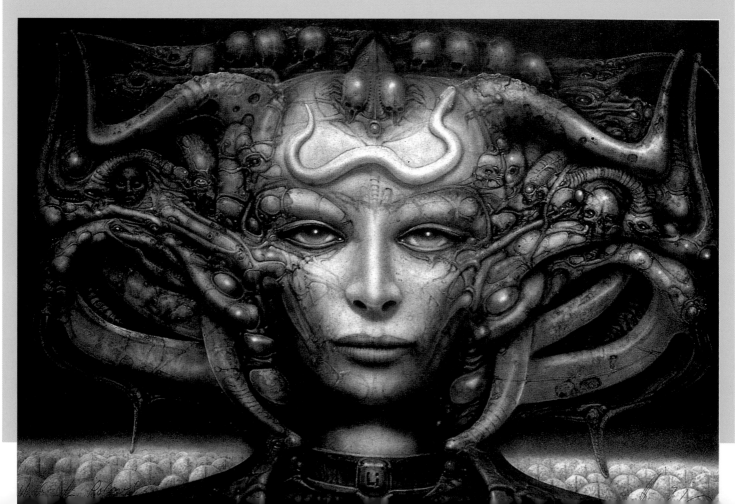

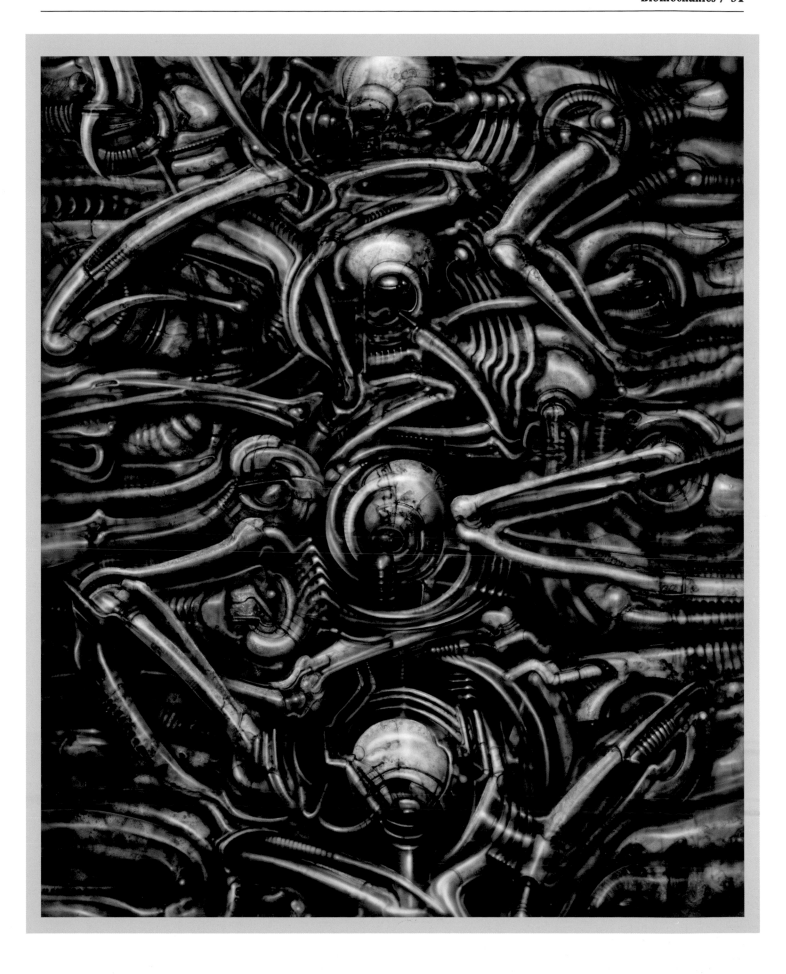

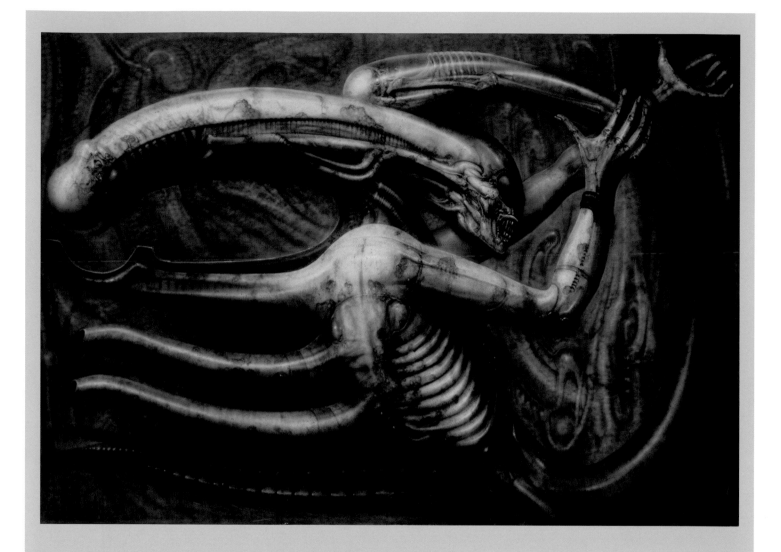

order: mechanical additions enhance the flesh and what was once bare skin appears to have acquired a body armour of sorts. Most biomechanical work is black and grey, as the original artwork is largely monochromatic, although, as you can see in these pages, applying colour can enhance the tattoo to a different level, no longer a mere reproduction but a custom-made reinterpretation. Mixing genres can also create beautiful results, such as the blending of biomechanics with tribal patterns.

Giger's work has also a place in esoteric art, where it transcends the visual world and, while mystical, it is in stark contrast to the conduits of organized religion. Necronomicon, 'an image of the law of the dead', first appeared in the 1920s as a fictional book of magic in H. P. Lovecraft's novels and is a phrase applied to some of the more disturbing esoteric imagery Giger has produced. There are many tattoos that depict darker incarnations of his surreal fantasy.

Working exclusively with ink on paper in the 1960s, Giger created most of his renowned artwork with an airbrush from the 1970s. He has, in recent years, concentrated on sculptures in aluminium and bronze, and also on drawing with ink on paper, revisiting techniques he first used in the late 1960s. While he greatly admires the work of the very best digital artists today, Giger himself eschews the use of computers and prefers to go back to basics in his own creation of art.

Disillusioned by the film industry, which used and abused his designs in equal measure – not even, for example, crediting him for *Alien Resurrection* – Giger is firmly settled in Zurich, where he works on his sculptures, produces his drawings, and keeps an eye on the Giger Museum. The museum, based in a château in Gruyère, houses his permanent collection and the Giger Museum Gallery, a three-room exhibition space to showcase artists exploring similar genres. Giger's own work is also frequently celebrated in museum exhibitions around the world, evidence of a global admiration of his art that shows no sign of diminishing.

The Giger Museum château also houses one of the two existing Giger bars in the world (both in Switzerland, the other one being in Chur, Giger's birthplace), a bar whose stunning interior décor gives the visitor the impression of having stepped into a 3D version of his designs. If you love the work, it's a destination not to miss. For those who cannot travel, the artwork continues to live and fascinate through his many books, which keep the Giger mystique alive.

A rock 'n' roll interpretation of the *Alien* creature, seen here playing the bass guitar in this witty piece. *Tattoo by Sergey, Kursk, Russia*

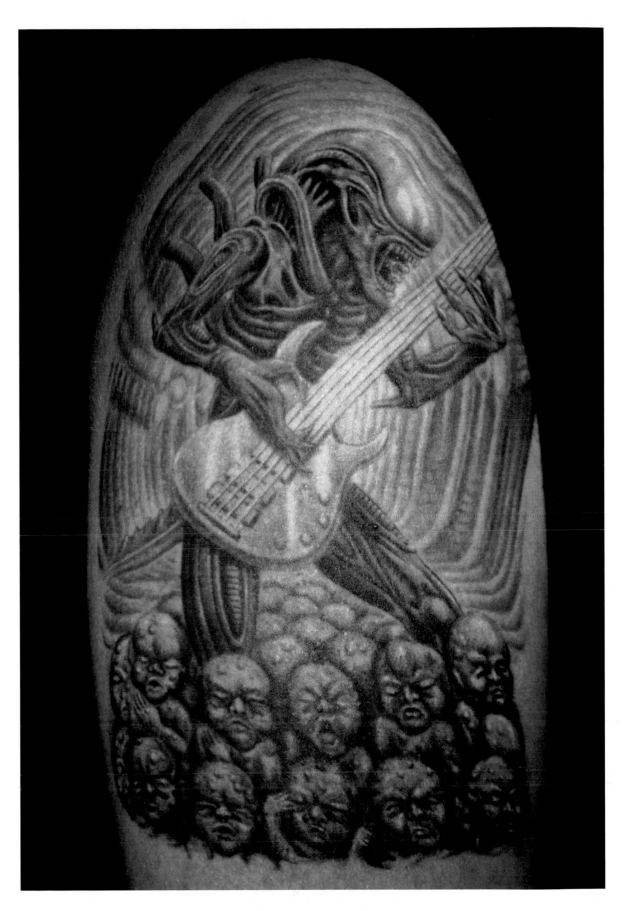

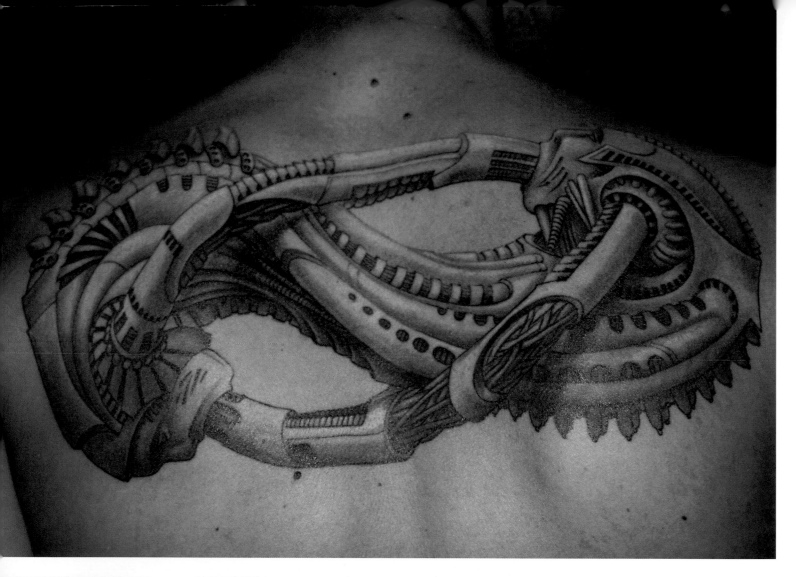

Above: Biomechanic machines in an endless embrace. *Tattoo by Kerber 88, Moscow, Russia*

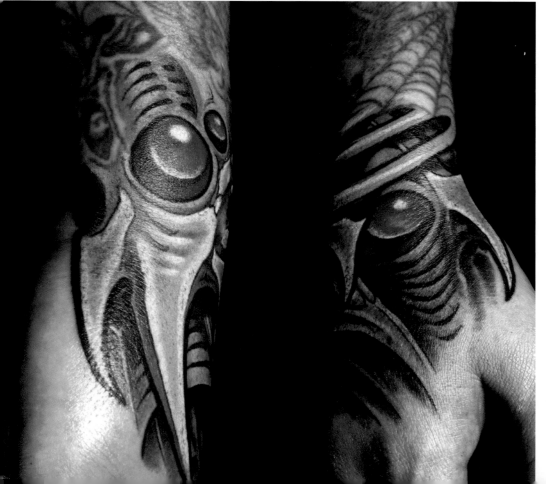

Left: Colour biomechanoid detail linking arm and hand. *Tattoo by Ron Earhart, California, USA*

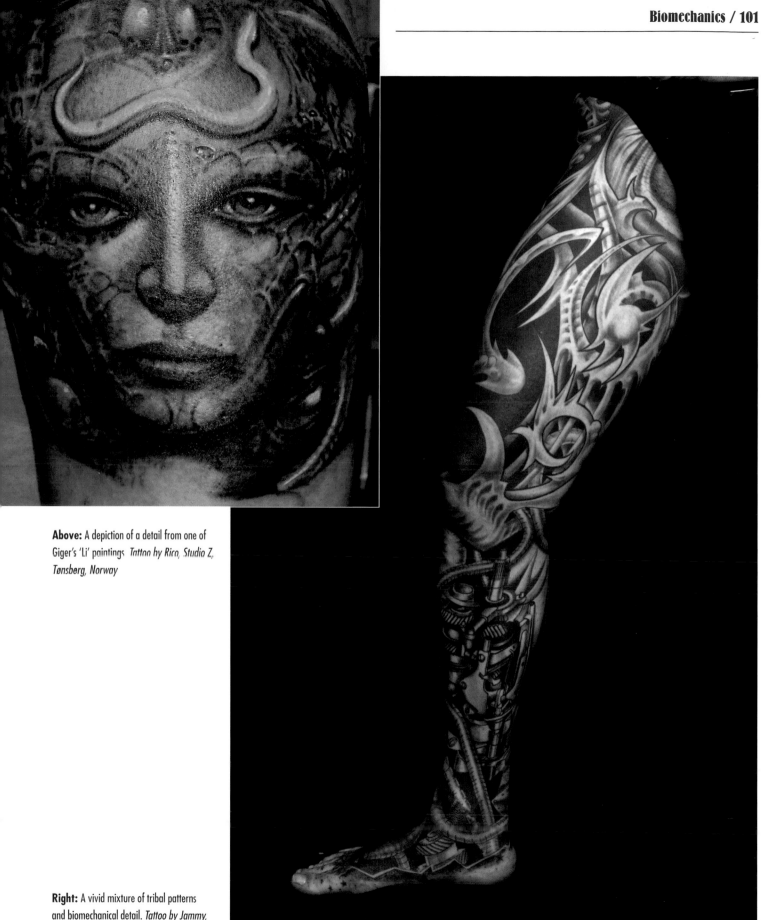

Above: A depiction of a detail from one of Giger's 'Li' paintings *Tattoo by Rico, Studio Z, Tønsberg, Norway*

Right: A vivid mixture of tribal patterns and biomechanical detail. *Tattoo by Jammy, Arles, France*

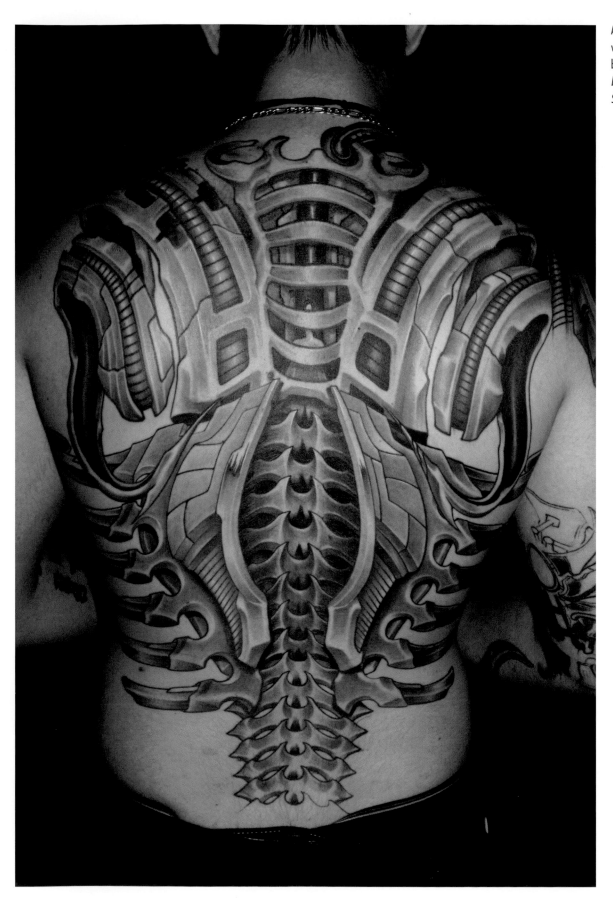

A biomechanoid spine with vivid red detail in a large black and grey piece. *Tattoo by Fadi Mikael, Geneva, Switzerland*

Wings that appear to be hooked into the skin, blending biomechanics and tribal work. *Tattoo by Sergei, Extreme Art, St Petersburg, Russia*

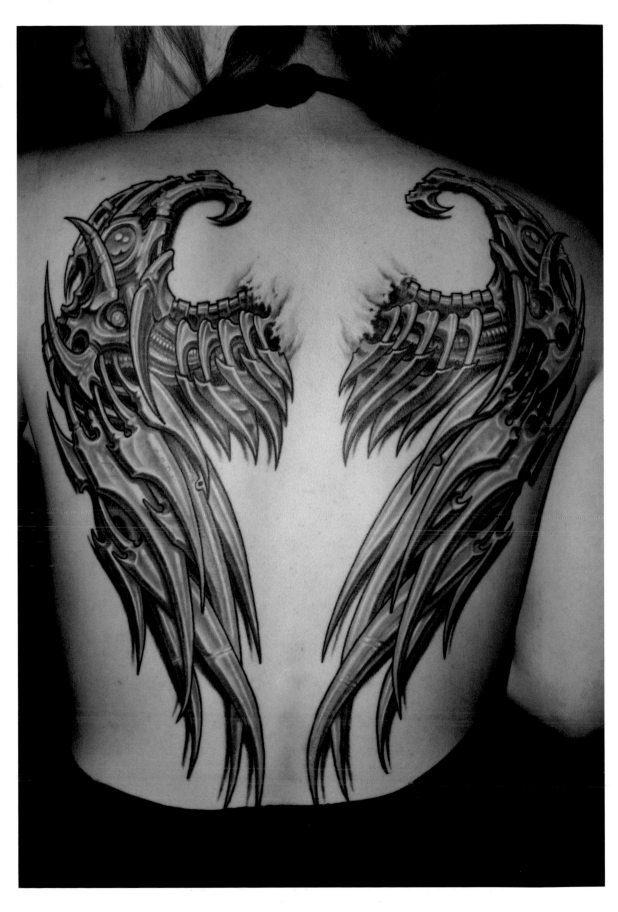

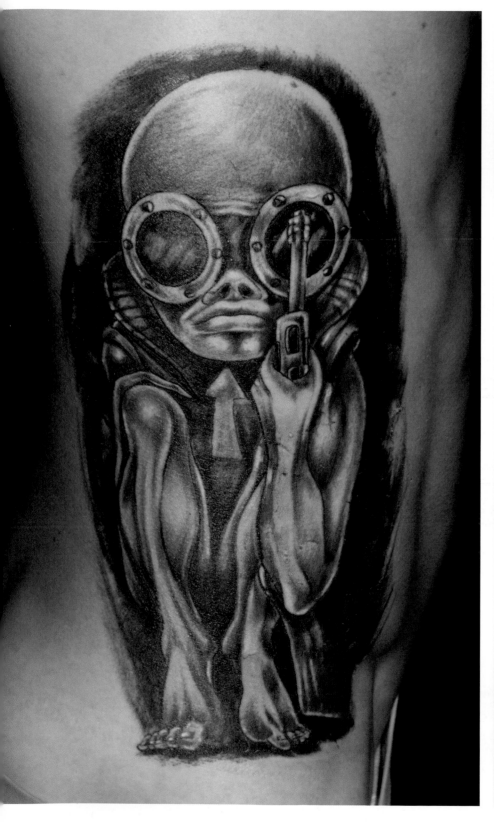

One of the birth machine babies which adorn
the entrance to the Giger Museum in Gruyère.
Tattoo by Alessia Reniero (on the road)

Tattoo by Mark Bailey, Golden Dragon

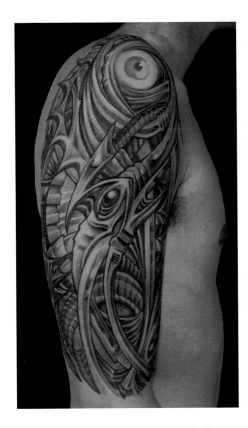

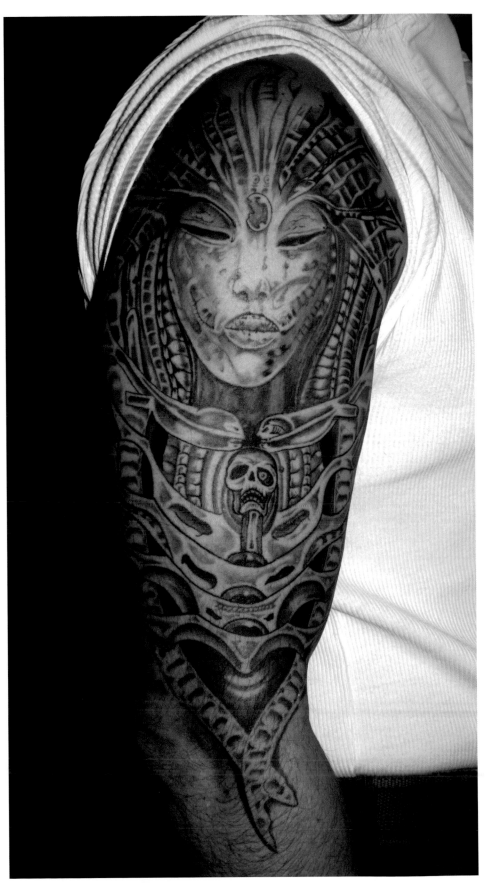

Two striking designs adapted for half sleeves (to the elbow), displaying the adaptability and versatility of biomechanic tattoo art. *Tattoos by (above) Elisa Tattoo, Italy and (right) Max's Tattoo, Baden*

The horror show

Horror movies have long wielded a strange power over the mainstream consciousness. The global success of horror stories has, until recently, depended largely on the big screen, despite the decidedly literary origins of the genre. The enduring visual appeal of classic horror movie icons like Frankenstein's monster and Nosferatu has been matched by more recent creations such as Hellraiser and Leatherface. *Saw*, *The Exorcist*, Michael Myers, zombies and several generations of vampires – from Bela Lugosi's Count Dracula to that of Gary Oldman – have all been celebrated far and wide by the medium of tattoo. Perhaps their shared characteristics – they are seen as rebellious, shocking and iconic – offer us an insight into why the tattooing world has so emphatically adopted the imagery of the horror genre. Successful TV shows such as *True Blood* have only intensified what was already a rich terrain.

Icons by their very nature are enticing and beguiling, and horror icons are arguably even more so, because they elicit an emotional or visceral response from us. Zombies, vampires and werewolves regularly feature in tattoos, sometimes organically linked to each other to create a large homage to the genre of the horror movie. As we will see in this chapter, many such tattoos are truly chilling, gruesome or disturbing, and they can prompt us to question why even horror dedicatees would choose to carry such images with them for ever more.

The answers are as numerous as the tattoos themselves: simple fan admiration; a genuine love of horror imagery or a particular fantasy monster; a desire to exorcise other ghosts; a desire to shock – the motivations are endless. And the tattoos themselves, if not to everyone's liking, are nevertheless unnervingly mesmerizing.

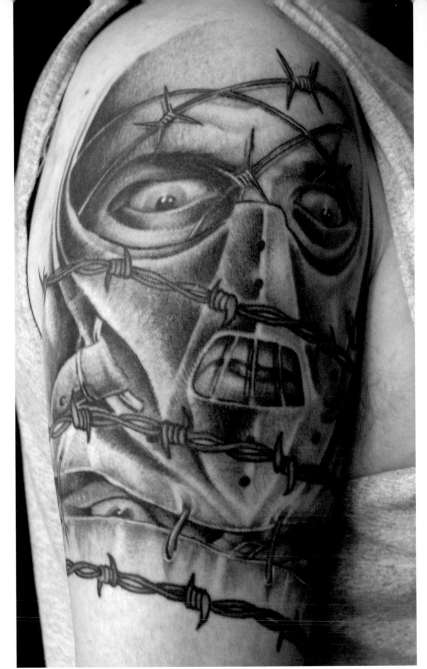

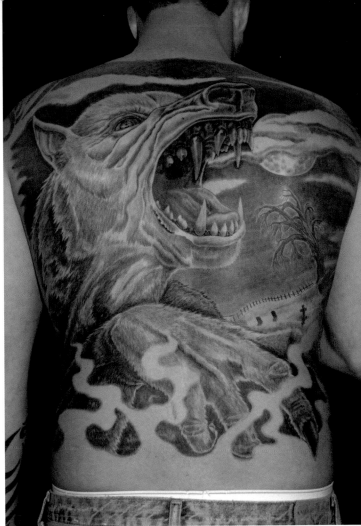

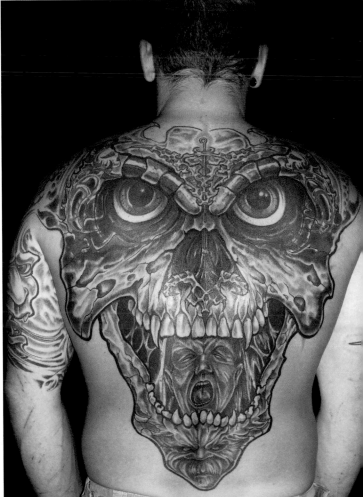

Above: An interpretation of the Hannibal Lecter mask surrounded by barbed wire by a master of black and grey work. *Tattoo by Jason Butcher, Immortal Ink, Chelmsford, UK*

Top right: A large piece portraying a werewolf howling in the light of the full moon. *Tattoo by Steve Prizeman, Eternal Art, Chelmsford, UK*

Right: A monstrous demon's features, in which you can spot other faces. *Tattoo by Bob Hoyle, Garghoyle Tattoo Studio, Elland, UK*

★ TRAILBLAZERS

Paul Booth

Paul Booth is the undisputed king of dark tattoo art. His nightmarish visions of demons rendered in beautifully nuanced chiaroscuro have the power to haunt and beguile in equal measure. The New York artist regularly travels the world attending tattoo shows and is easy to locate: his will be the booth hidden from sight by the mob of diehard fans who have travelled from afar just to watch him work — or who are hoping to be tattooed by him.

If you thought that artistic visions of hell are a niche market, think again: Paul Booth is booked up well over a year in advance. It appears there are many who want to exorcise their demons by wearing them on their own skin…

A true trailblazer, Booth is one of those rare artists who pioneer a particular style and end up unwittingly creating a genre. Today, the world over, scores of artists remain heavily influenced by him and his artwork. When his designs started appearing in the early 1990s, no other tattoo work had ever dared to reveal such horrific visions.

Curiously, but perhaps not surprisingly, Paul Booth was brought up as a Catholic, and he likes to think of himself as a product of the Church, although he belongs to no organized religion, either mainstream or alternative. His powerful images were until recently created mostly in monochrome inks, although he has started to push the boundaries by mixing specific colours to his designs in order to affect the tattoos' contrast. His work is applied to the skin in a very organic way: unlike most artists, Paul Booth eschews outlines as a starting point, preferring his tattoos to take form more freely, without the constraints of an outside border. Outlines are usually added at the final stages to finish the tattoo off.

Having tattooed a number of rock stars (Pantera, Slipknot, Slayer and Machinehead, to name but a few), Paul Booth can be confident that his work has entered the public consciousness on a broader platform; but despite this, he has not forgotten his roots and regularly stages exhibitions of like-minded work at his Manhattan shop Last Rites.

As he admits himself, his work is not for everyone. He always makes a point of chatting with his clients to ascertain if they can actually wear it: they are, after all, the ones who will have to live with it.

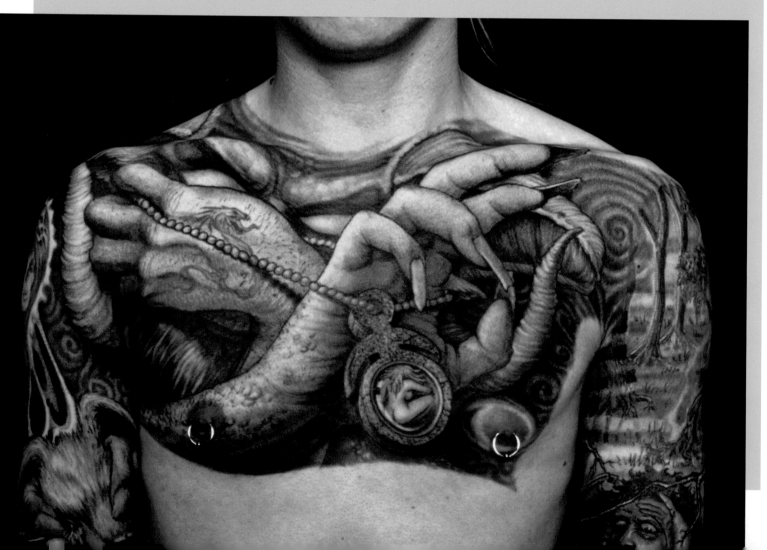

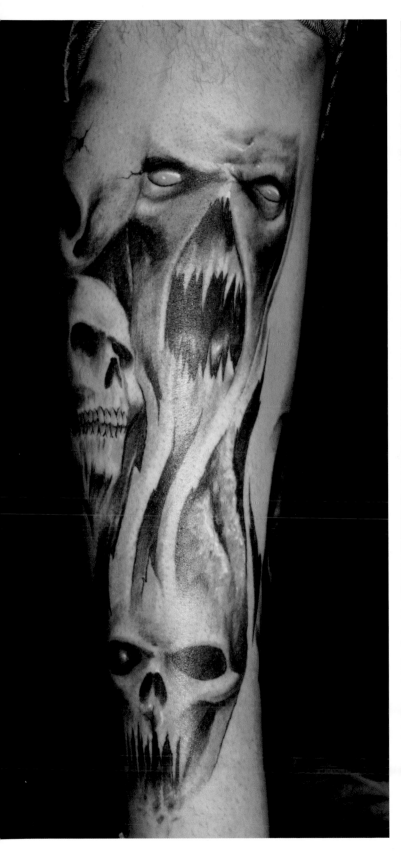

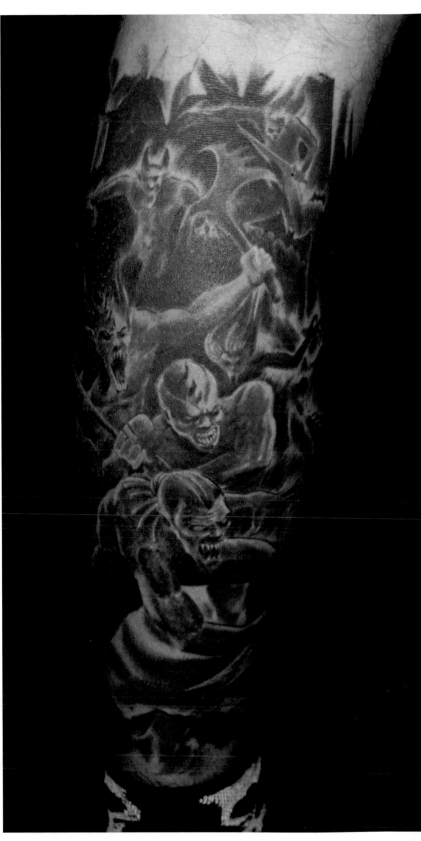

An armful of demons. *Tattoo by Patrick, Tattoo Devil, Berlin, Germany*

More demons, this time in glorious fiery tones. *Tattoo by Bloody Blue Tattoo, Prague, Czech Republic*

★ TRAILBLAZERS

Liorcifer

Based in New York, Liorcifer co-runs a tattoo studio with two colleagues. He specializes in eerie and demonic subject matter, and his influences become clear when you learn that his interest in tattooing sprang from his love of heavy metal and black metal music, especially its distinctive album cover artwork.

Born and bred in Israel, where his interest in the visual arts first manifested itself, Liorcifer initially expressed his love for the artwork of metal music by getting it tattooed on himself; later, he went one step further by getting an apprenticeship in Tel Aviv. With a desire to spread his wings, and aware of the limitations of working exclusively in his home country, Liorcifer left Israel for the United States at the age of 21. After a short period in a Miami studio, he moved to New York where he secured a part-time apprenticeship with Paul Booth (see page 108).

After a gruelling initiation, Liorcifer was taken on full-time at Booth's Last Rites. If Liorcifer's moody black and grey work is reminiscent of Booth's, it is because the two men share a taste for a specific type of demonic imagery and because they worked together so closely for seven years. Liorcifer went on to open Tribulation in New York's Lower East Side with two other Last Rites stalwarts, Dan Marshall and Tim Kern. The three are equal partners in the shop, which runs by appointment only, and they have their own specialisms, although they are all drawn to the darker subject matters in life.

Making up for his lack of formal art education with a huge determination to be a good artist, Liorcifer is proof that talent plus hard work and a willingness to learn can allow you to reach your goals. His humility is testament to his commitment to his craft: 'You are forever an apprentice — you never stop learning,' he says. His work is ideal for large canvases like back pieces or bodysuits, which allow a bigger story to be told, but it also looks striking when adorning smaller body parts, as it is rich in tonal range and exquisitely crafted. For a dynamic piece with little colour and a dark/macabre subject matter, Liorcifer is the ultimate go-to man.

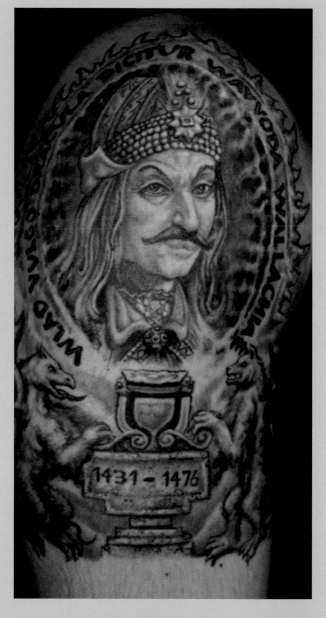

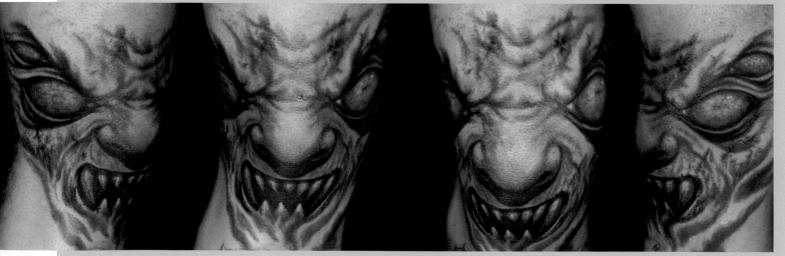

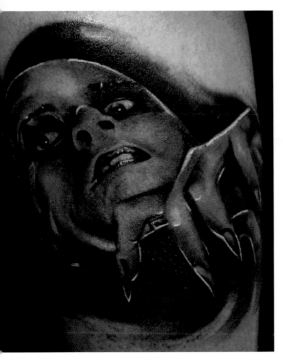

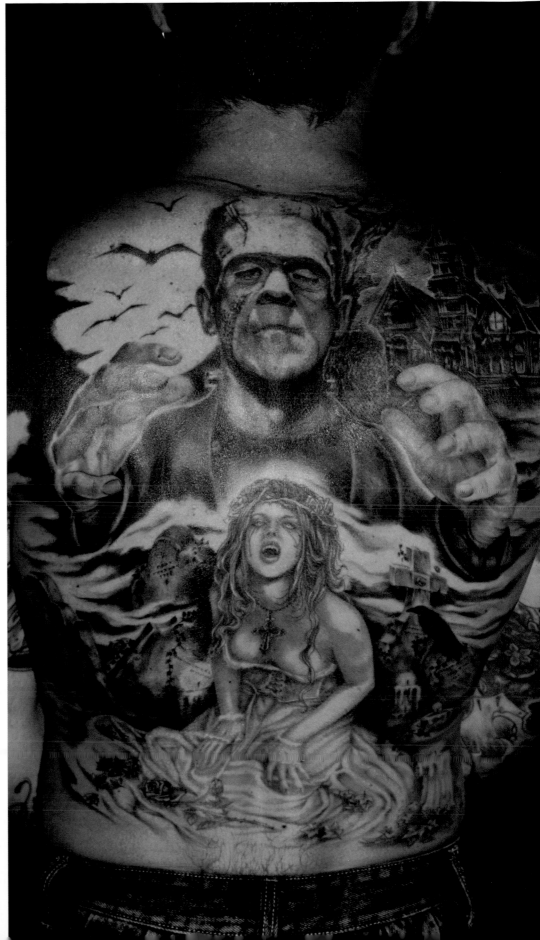

Above: Nosferatu might have been defeated, but the imagery (from the Werner Herzog version) lives on. *Tattoo of Klaus Kinski by Gabriele, Laboratorio di Mutanti, Italy*

Right: The timeless haunting tale of *Frankenstein*, here with a vampire twist. *Tattoo by Jordi Pinzell, Physical Tattoo, Playa de Aro, Spain*

Below: A fantastical and nightmarish vision, this is a highly elaborate back piece and yet every detail stands out clearly. *Tattoo by Heiko, Eastside Tattoos, Magdeburg, Germany*

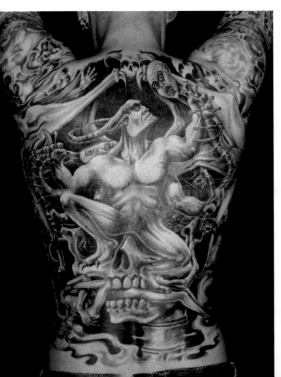

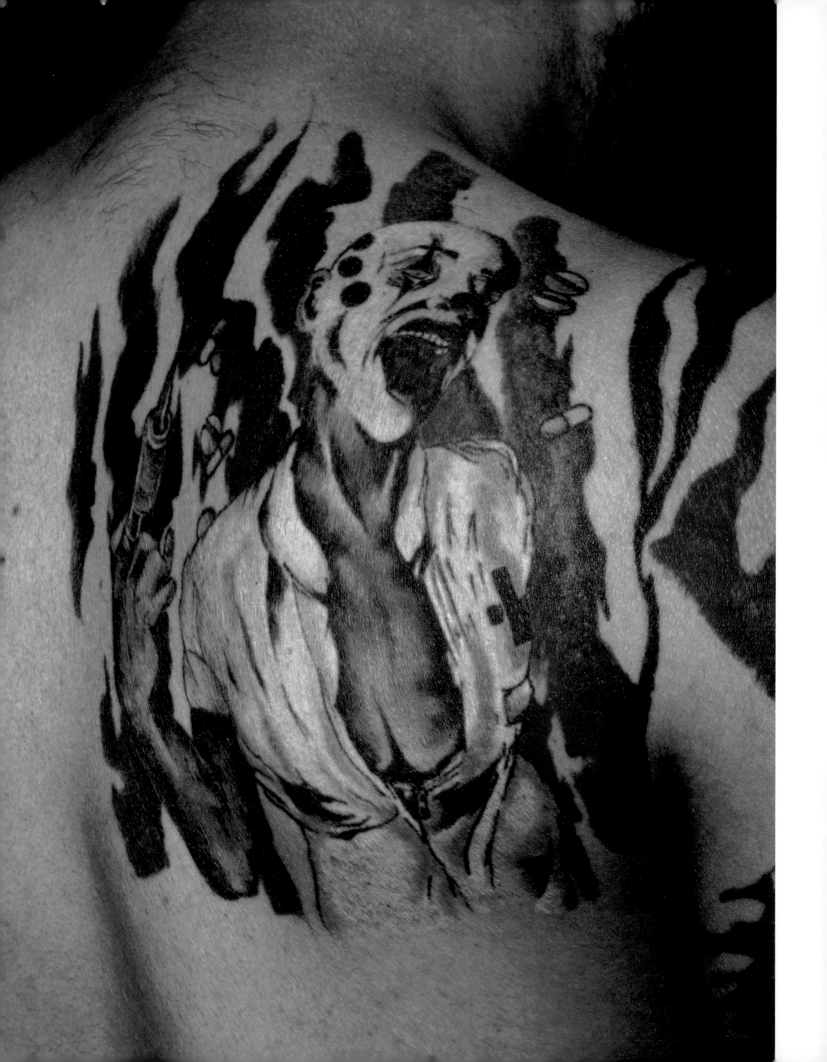

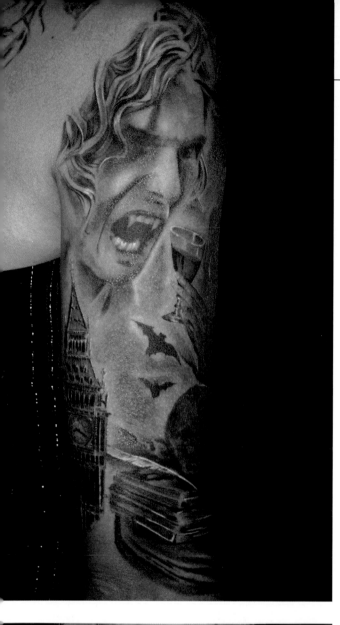

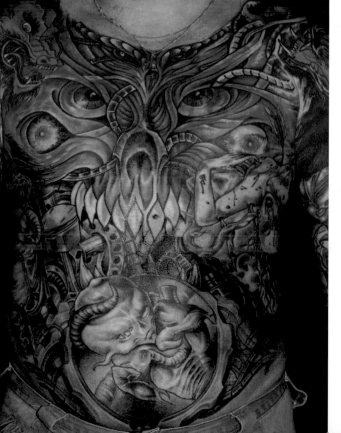

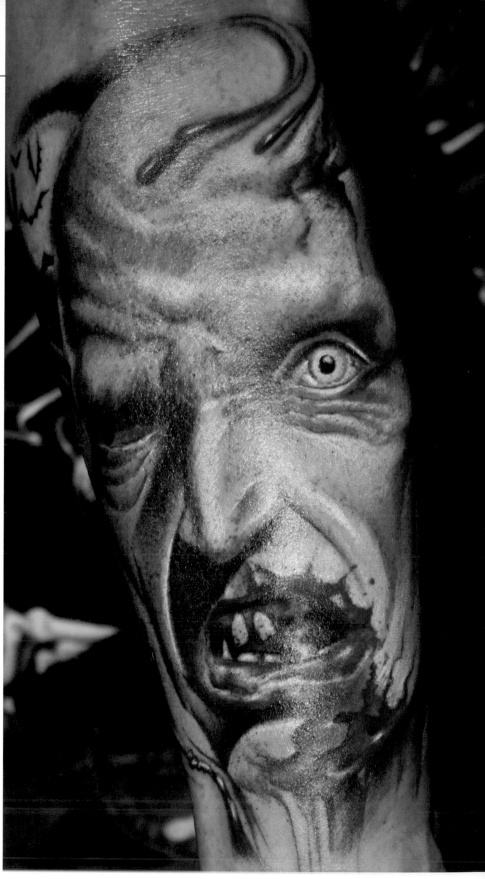

Opposite page: A mad nurse with a dangerous-looking syringe. *Tattoo by Leslie Chan*

Top left: Black and grey remain popular hues to render vampire tattoos, conjuring up a classic movie feel. *Tattoo by Miguel Angel, V-Tattoo, Valencia, Spain*

Above: Straight from a special FX artist, bloody close-up (*by Bloody Blue Tattoo, Prague, Czech Republic*)

Bottom left: Demons crowd this piece which incorporates an alien foetus, machines and humanoid figures. *Colour tattoo by Rob Doubtfire, black and grey abdomen by Jason Butcher, Immortal Ink, Chelmsford, UK*

Life in monochrome

Gone are the days when old black tattoos faded with time to become blurry, blue and indistinct. New types of machines and needles, the variety of inks available and more sophisticated needle-work have enabled tattoo artists to ensure that the likelihood of our precious tattoo becoming ill-defined and losing its impact is not something we need to worry about.

Whereas old-school black tattooing techniques were bold and oftentimes rather crude, these practical advancements, combined with a new generation of artists specializing in delicately nuanced black and grey tattoos, have breathed new life into this genre. Once the almost exclusive realm of tribal and biomechanical work, black and grey is now the work of choice for those who eschew wearing colour and for all those designs where it would be intrusive and unnecessary. For example, black is the ink of choice for writing on skin: slogans, mantras, significant dates, a loved one's name – all are usually tattooed with this boldest of tints.

Black and grey is often used to render realistic portraits, script tattoos and tribal and line work, resulting in tattoos that have impact but in which there are no different colours with the potential to fade into one another.

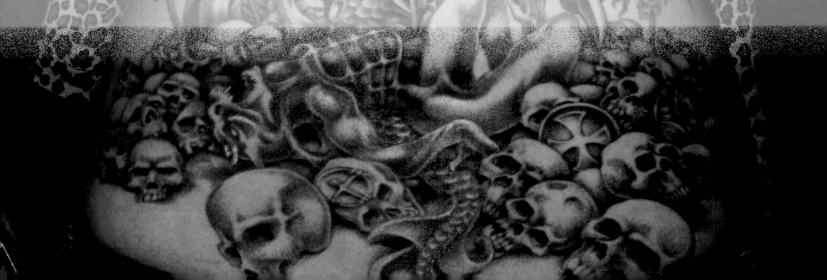

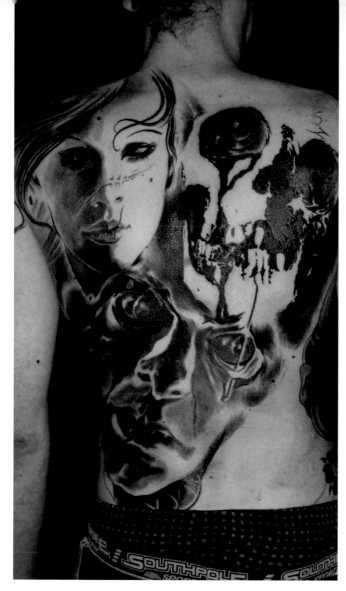

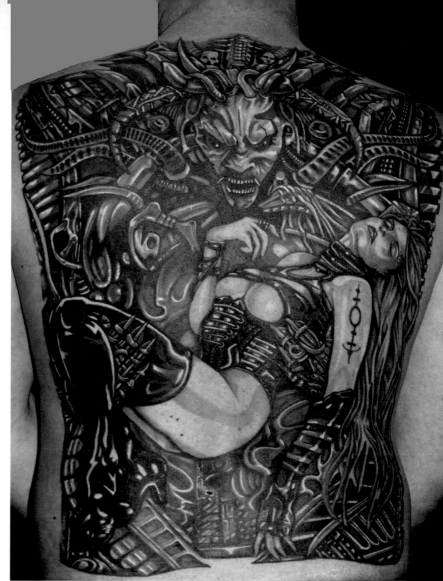

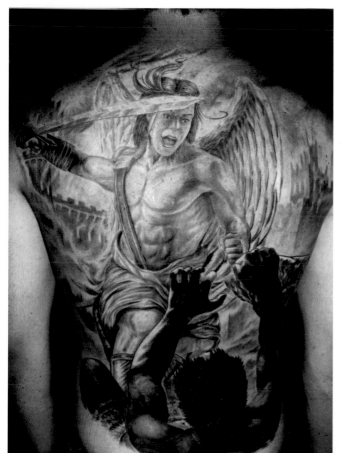

Top right: A biomechanoid demon carries off a scantily clad (and tattooed) beauty. *Tattoo by Oz, Sinister Scrawlings*

Top left: A bold back piece which blends three close-ups in high contrast black and grey, revealing a strong graphic influence. *Tattoo by Christian Benvenuto*

Left: An exterminating angel or a judgement from above? The ethereal angel passes a sentence on to the earthly, darker man. *Tattoo by Gerhard Wimmer, Wild Art Factory, Echsenbach, Austria*

Right: A lattice-like cord pattern which covers the whole arm yet leaves plenty of non-tattooed skin. *Tattoo by Alex, A True Love, London, UK*

★ TRAILBLAZERS

José Lopez

José Lopez is the author of some of the most breathtaking black and grey tattoos that you will ever see. Judge for yourself in these pages.

His origins as a chicano artist are clear to see: many of his tattoos emerge from the influence of Latino gangs, and his work contains many icons specific to ghetto culture. What sets his work apart from that of his contemporaries is the delicate touch of his tattoo gun. It is difficult to comprehend how a machine with moving needles can be controlled to inject ink in such a subtle and fluid way. Lopez's use of grey tones is both accurate and perfectly nuanced. His portraits are of photographic quality, and it is remarkable to see the way he mixes different elements like portraits and text, without weighing the body down with his tableaux.

Despite having been caught in the crossfire of gang gunfire which caused permanent spinal damage and confined him to a wheelchair, José Lopez has not allowed his disability to hinder his development as a tattoo artist. Indeed, he admits his life could have taken a different and darker turn if it weren't for the accident. His commitment to his art is admirable, and the consistency and quality of the tattoos is the result of simple hard work. His accomplishments are all the more remarkable as he does not have full freedom of movement, making it physically difficult to tattoo certain body parts. To add to his prodigious talents, Lopez is also well-known and admired for his paintings, owns the successful Lowrider studios in Southern California and has a clothing line, featuring his trademark bold black and white images, stunning girls and 'street style' artwork.

José Lopez's approach allows all his themes to interlock with each other, creating seamless tapestries on skin that are able to convey a sense of self in an almost dreamlike sequence. He is not only applying his black and white visions on skin: he translates accurately the wishes of his clients into organic pieces composed of many elements, all competing with each other for beauty and grace.

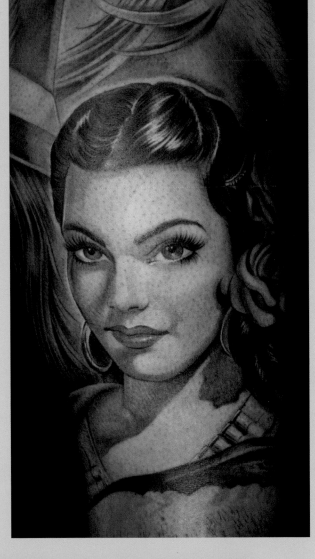

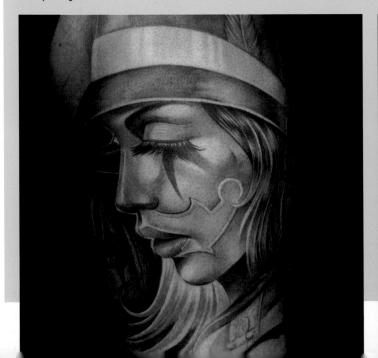

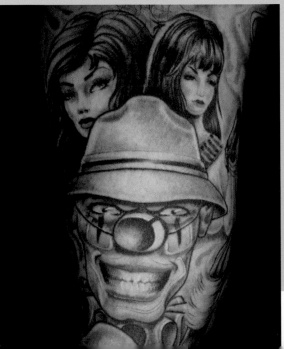

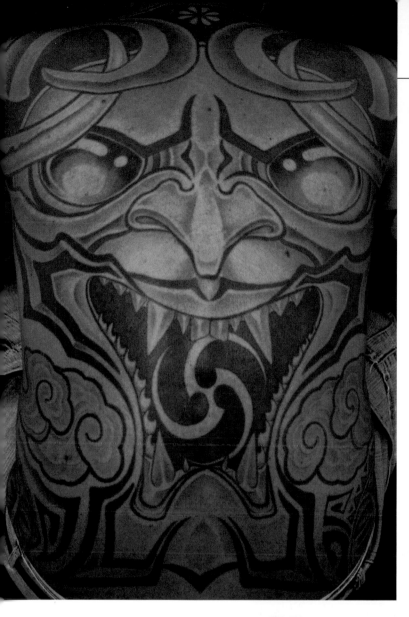

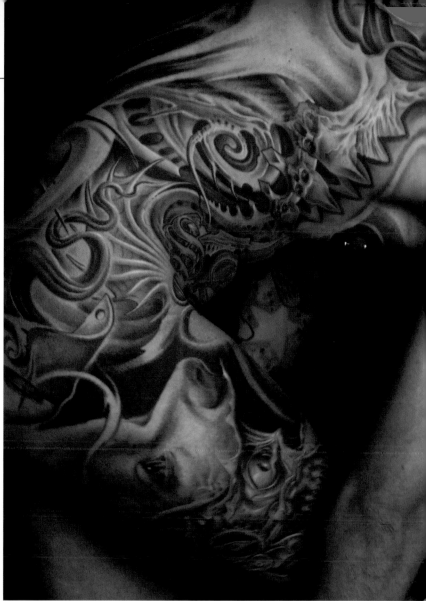

Above: An eye-catching, bold design for a back piece which is made up of a large black and grey tribal face. *Tattoo by Dino Immacolato, Italy*

Top right: A stunning bodysuit rich in tonal range and beautifully adapted to the man's body. *Tattoo by Victor, Portugal*

Right: Detail of a black and grey bodysuit, here focusing on the ever glamorous Marilyn. *Tattoo by José Lopez, Downrider Tattoo, California, USA*

Far right: *Tattoo by Max, From Hell, Gloggnitz, Austria*

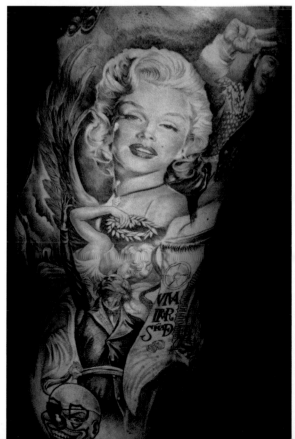

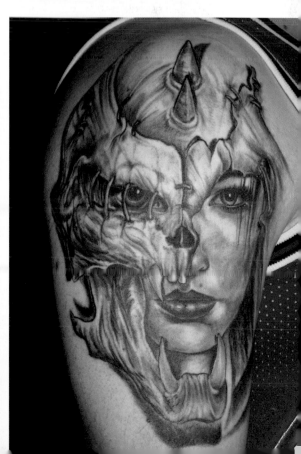

★ TRAILBLAZERS

Boog

Boog's celebrity status in the tattoo world is only surpassed by that of his famous customers. With a client list that includes pop stars, TV personalities, models and porn stars among others, Boog has arguably done some of the most high-profile work in the business.

He is famous for his bold yet delicate black line work and he has produced a bestselling line of flash artwork (sets of tattoo designs that can be used by anyone), allowing countless other artists to pay homage to his style. These sheets offer examples of his work, but each is a work of art in itself: each has a theme, and the various elements that comprise the sheets flow effortlessly into each other. They look simple, yet they are anything but: their appearance of simple black lines and shading has taken years of hard work and refining.

Boog's air of 'gangsta' tattooist is compounded by his imposing presence and by his ignoble beginnings: born in a poor part of Dallas, Texas, he started his tattoo career with a handmade machine procured from a guy fresh out of jail. Boog took to tattooing and started to ink the people in his neighbourhood. His art was, by his own admission, what kept him out of trouble, but he never forgot his origins, and his style is reminiscent of a certain 'bling' aesthetic which is seeping into the mainstream thanks to music videos, album cover art and, of course, tattoos.

His aesthetic was informed early on in his career by the chicano art that was all around him. Although he is fundamentally a tattoo artist and works primarily in monochrome, Boog loves graffiti, incorporating it in his tattoo work.

Boog makes no mystery of the fact that he charges high prices for his work, and one can only admire a man who knows his worth. He wants people's custom only if they really want his work: if they could get something similar somewhere else, he is simply not interested. 'With each tattoo,' says he, philosophically, 'you give a little bit of yourself to the person who wears it.' That makes each custom piece rather special.

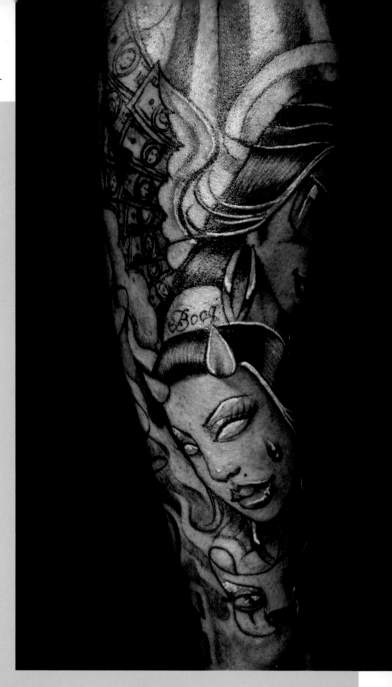

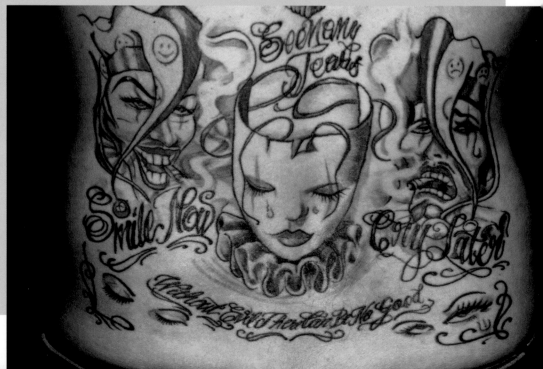

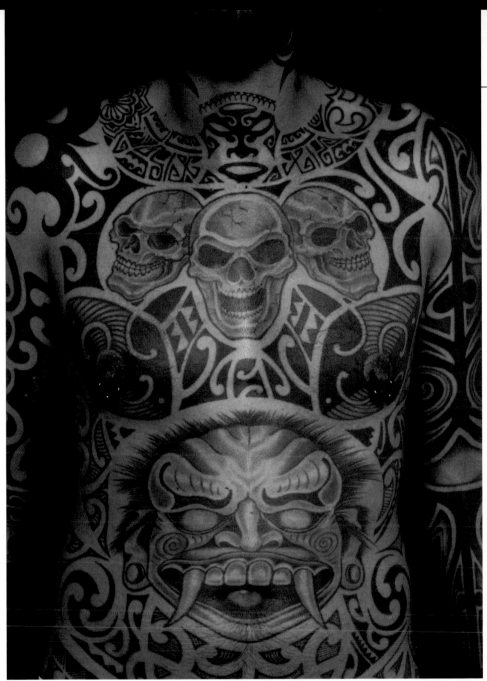

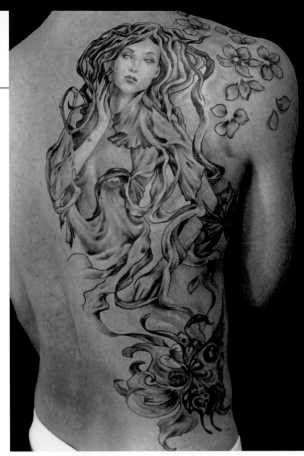

Four tattoos, four different styles that encapsulate the richness and variety of work that can be achieved in black and grey. *Tattoos by (clockwise from above): Dino Immacolato, Luca di Torino and Roberto, Buttigliera Alta, Italy; Elisa Tattoo, Italy; Eric De L'Etoile, Quebec, Canada; Nightliner, Berlin, Germany*

Pushing the boundaries

We have looked at tattoo traditions around the world, at different techniques and pioneering work. We are exposed to tattoos through television, in magazines, on cinema screens, and on the people we meet every day. Tattoos no longer hold shock value. Or do they?

As tattoos become more ubiquitous in societies the world over, pushing the boundaries takes more extreme measures. While some people choose to do so with obnoxious, offensive or racist subject matter (and there is plenty out there), others select a less disrespectful route and tattoo parts of their body that are usually left untouched by ink.

For those who take the second option, the most common body parts chosen for inking are the face, hands and neck – and not only as last resorts when they have run out of space elsewhere on their body. Starting with tattoos that will hardly ever be hidden can mean waving goodbye forever to a conventional job and inevitably means letting the ink be the first thing that will be noticed about them. It is a most personal and virtually irreversible life choice, and not a decision to make lightly. Facial tattoos mean different things in different cultures. In some societies they indicate status and are deeply-rooted customs, whereas in others they are just decorative. Either way, they still have the power to shock.

Elsewhere the boundaries can be pushed by dabbling in the unknown, the experimental and the avant-garde. The Polish School of Art, Boucherie Modern and Buena Vista art groups, among others, have all been highly influential in paving the way into the future of tattoo. From three-dimensional images and UV ink to bizarre and unprecedented designs, these groups are forging ahead into a brave new world of tattoo to ensure that, for this art form at least, the future is a bright and exciting place.

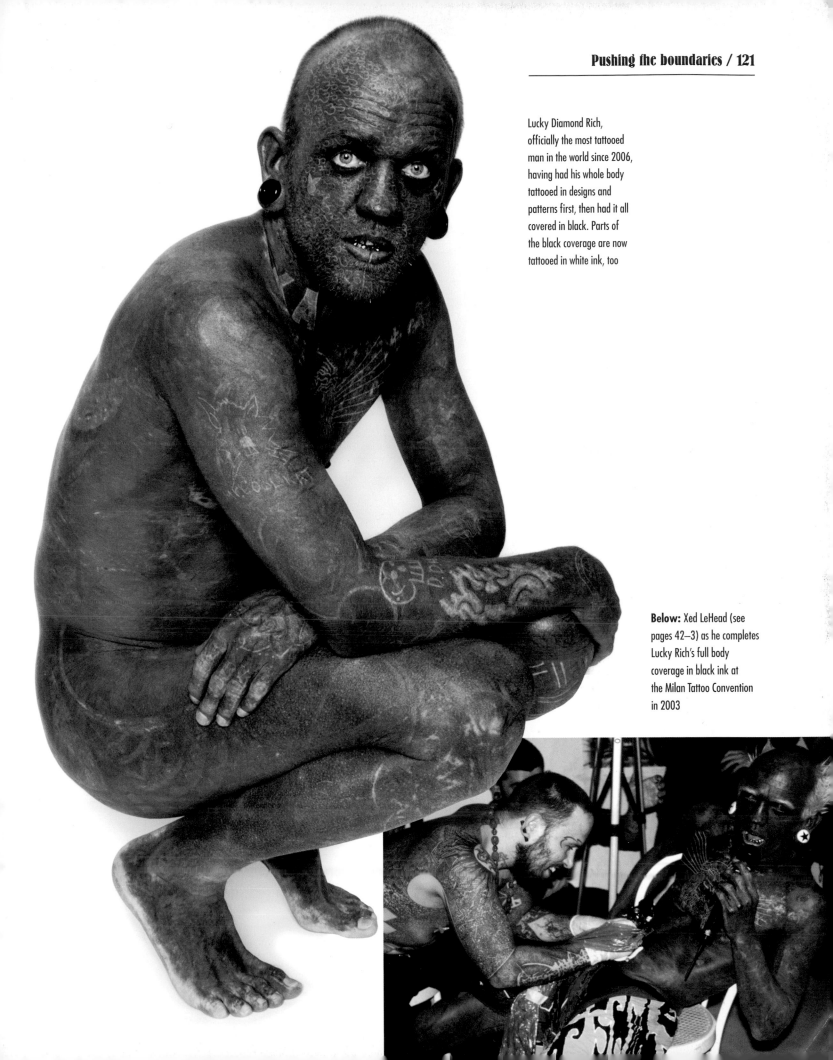

Lucky Diamond Rich,
officially the most tattooed
man in the world since 2006,
having had his whole body
tattooed in designs and
patterns first, then had it all
covered in black. Parts of
the black coverage are now
tattooed in white ink, too

Below: Xed LeHead (see
pages 42–3) as he completes
Lucky Rich's full body
coverage in black ink at
the Milan Tattoo Convention
in 2003

Isobel Varley, since the year 2000, is officially the most tattooed senior citizen in the world. Isobel's transformation has happened relatively recently: she started what was to become her bodysuit after visiting the London Tattoo convention in 1986

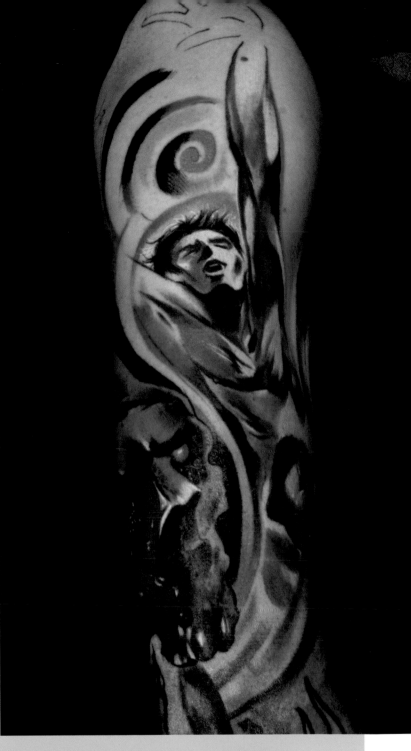

★ TRAILBLAZERS
The Polish School of Art

Some of the most prodigious work produced in the tattoo world today comes from Eastern Europe. Polish tattoo art in particular has had a huge impact on Western techniques and the use of colour. When Poland joined the EU in 2004, its population started to cross borders, and so did a number of incredibly talented tattoo artists. Poland has a strong tradition of surrealist art. For years this was chiefly visible on theatre and movie posters: rarely was a movie released in Poland without a new poster by a local artist. Tattooists hardly ever travelled to tattoo shows; the conventions were scarce, and most art to come out of Poland was visible only in Berlin, which, because of its proximity, used to be a particular hotbed of Polish art.

What started as an incredibly skilled and fantastical art tradition, which encouraged its pupils to delve into their own minds rather than be shaped by popular culture, eventually began to influence a whole generation of tattooists to create work so vibrant it seemed to leap off the skin. These talented young artists use their imagination unbridled by outside influences, producing work which is bright, colourful, cleverly constructed and wonderfully imaginative. They have translated to skin the skills they have learnt in painting, such as gouache and oil pastel techniques, raising the bar for colour tattoo work. Artists like Robert Hernandez (born and trained in Poland), Tofi and Kamil, to name just a few, have become unrivalled masters of colour realism, a genre which has successfully crossed borders and garnered acclaim and awards.

The new Russian Republics also harbour a hotbed of tattoo talent, whose work is rarely seen by the outside world because of communication (they use the Cyrillic alphabet) and accessibility difficulties. Before the dissolution of the Soviet Union, these incredibly talented artists were forced to develop their styles and techniques without the influence of visual information stemming from the Western media. Their relative isolation allowed them to achieve excellence in their chosen field, and now they have travelled to the West and have found fertile ground for spreading their techniques and vision.

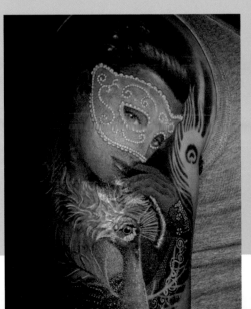

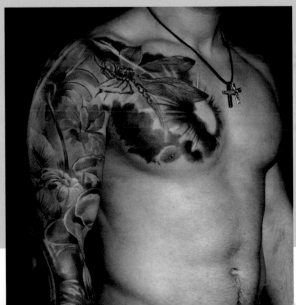

Top and far right:
Tattoos by Kamil, London
Right: *Tattoo by Anabi Tattoo, Poland*

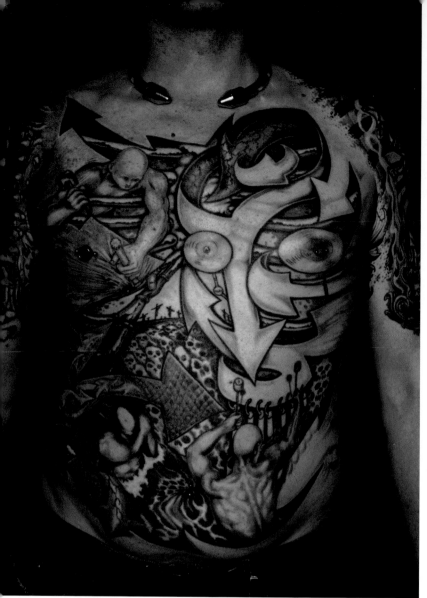

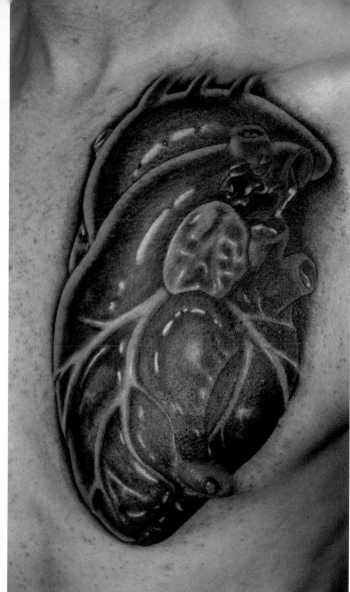

From the sublime and bizarre to the seemingly unfathomable, the modern tattoo emphasizes, above all else, the beauty of the individual.

Above: A fantastical design. *Tattoo by Rabbit, Grin 'n' Wear it*

Top right: A heart is not always old-school and with an arrow going through it: this one reveals great anatomical detail. *Tattoo by Marc, Sigi's Tattoo Family, Linz, Austria*

Right: A bold black design of three humanoid figures. *Tattoo by Zoe, Tatau Obscur, Berlin, Germany*

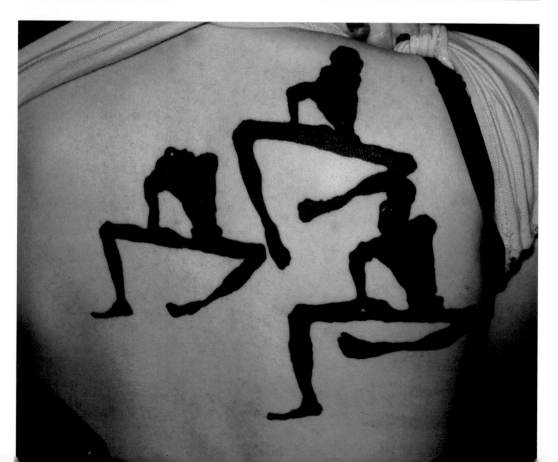

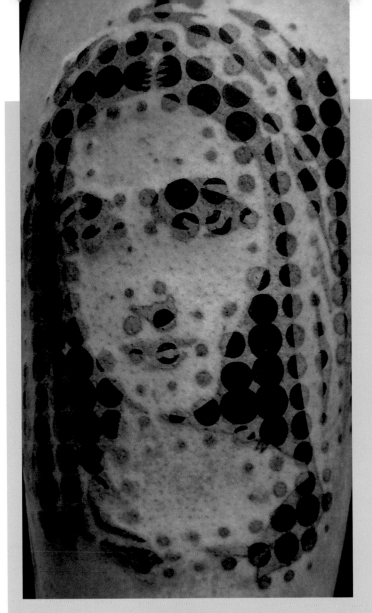

Pioneering the Future

Tattoo work has a long and rich history, and as we have seen in these pages, there is a wealth of material in tattoo designs by which to be inspired. Old themes can be reinterpreted with a modern sensibility, and the more sophisticated machines now in operation allow artists to explore new techniques. Is there anything else left to explore?

A new breed of tattoo artist has started to investigate the possibilities offered by 3D, UV and graphics techniques, incorporating design elements into more traditional ideas and, in doing so, utterly revolutionizing the tattoo genre. The work emerging from studios like Boucherie Moderne (in Brussels), Buena Vista Tattoo Club (in Würzburg) and Viva Dolor (in Lyon) is truly mindboggling, innovative and original. The way in which these artists conceive a tattoo and produce the artwork subverts all the rules that have, until now, been faithfully followed.

The backgrounds of these pioneering tattoo artists encompass fine art, photography, graphics, design and illustration and it is not surprising, therefore, that all these influences are fused together in creating such pieces. Using computer graphics, old printing techniques and pixilation, the image is deconstructed and rebuilt on the skin. But despite such modern reproduction techniques, each of these deeply visceral tattoos is unique.

These artists see reality in an entirely unconventional way and they filter their work through their own singular vision. Their work is not for everyone, but if you like it, you'll fall in love with it. There will always be a market for more orthodox work, but the future starts here.

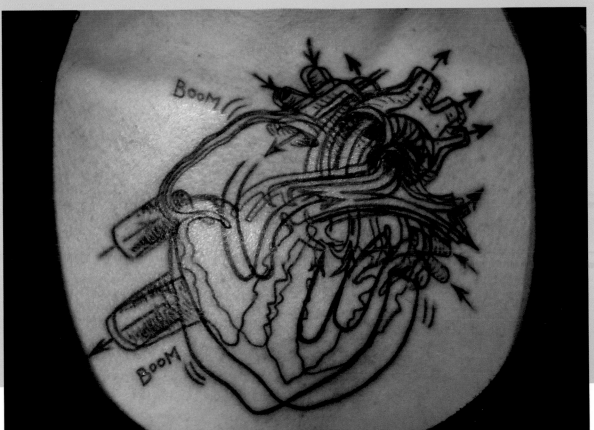

Above and right: *Tattoos by Jef, Boucherie Moderne, Brussels, Belgium*

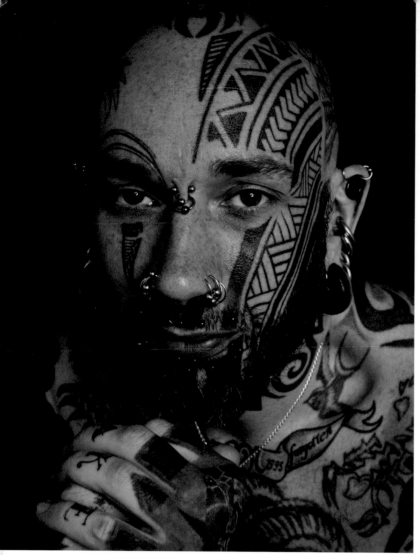

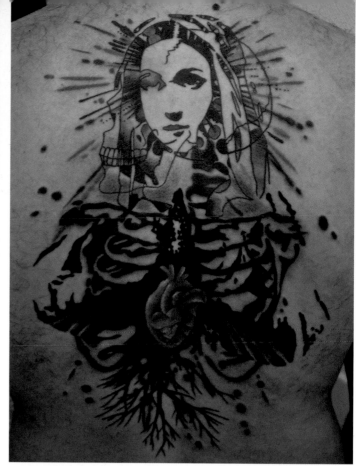

Above and bottom right: Facial tattoos are still rare, although we see more and more. Above, this tribal pattern frames the wearer's features beautifully. *Tattoos by (above) Jack Mosher and others, and (right) Boris, Hungary*

Top right and below: Two amazing pieces by Jef. These encapsulate the new frontiers continually pushed by the fresh generation of tattoo adventurers: traditional designs which have been deconstructed and demystified. *Tattoo by Jef, Boucherie Moderne, Brussels, Belgium*

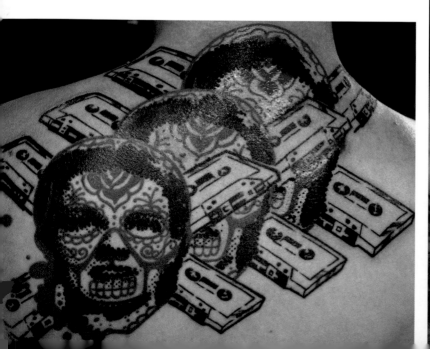

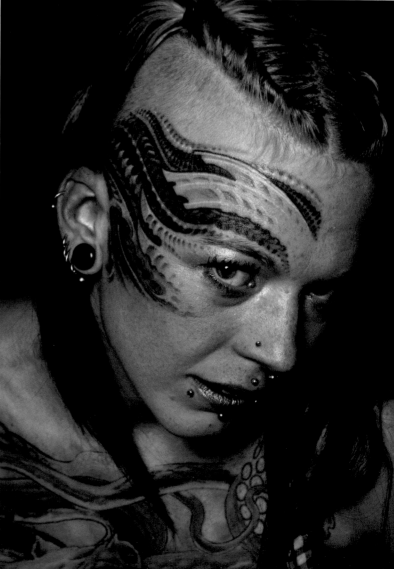

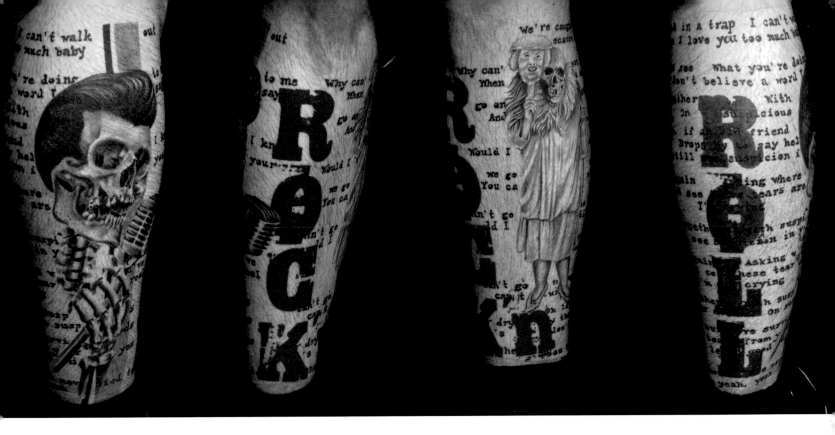

Above: The inimitable style of Buena Vista — a mix of graphics, illustrations and text in a striking design. *Tattoo by Buena Vista Tattoo Club, Würzburg, Germany*

Below: A surreal snowman moment. *Tattoo by Tataj, St Petersburg, Russia*

Useful links

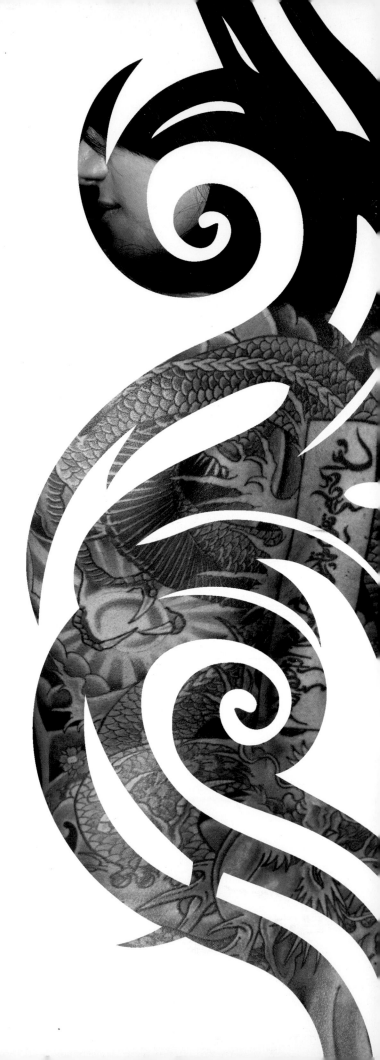

Alex Binnie	www.alexbinnie.com
	www.into-you.co.uk
Boog	www.boogstartattoo.com
Boucherie Moderne	www.boucheriemoderne.be
Buena Vista Tattoo Club	www.buenavistatattooclub.de
Bugs	www.bugsartwork.com
Filip Leu	www.leufamilyiron.com
George Bone	www.georgebonetattoos.co.uk
Joe Capobianco	hopegallerytattoo.com/joe-capobianco
H.R. Giger	www.hrgiger.com
Horiren	www.horiren.com
Horiyoshi III	www.ne.jp/asahi/tattoo/horiyoshi3
José Lopez	www.lowridertattoostudios.com
Kamil	www.kamiltattoos.com
Liorcifer	www.liorcifer.com
	www.tribulationtattoo.com
Paul Booth	www.darkimages.com
Robert Hernandez	www.rhernandeztattoos.com
Shige	www.yellowblaze.net
Tofi	ink-ognito.pl
Xed LeHead	divine-canvas.com

With thanks to

Alex Binnie, Berit Ulhorn, Bugs, Elisa Tattoo, Emma
Griffin, Garry Hunter, George Bone, H.R. Giger, Jef@
Boucherie Moderne, Jessica Cole, Leo@Naked Trust,
Lepa Dinis, Les Barany, Liorcifer, Marion Thill.